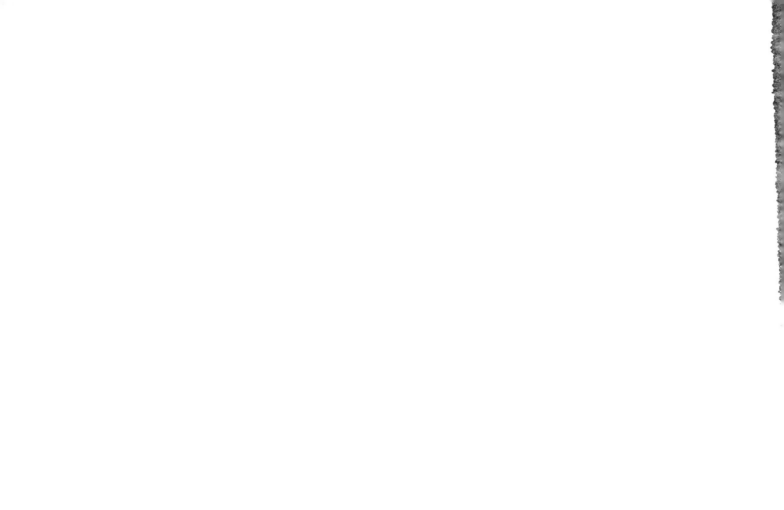

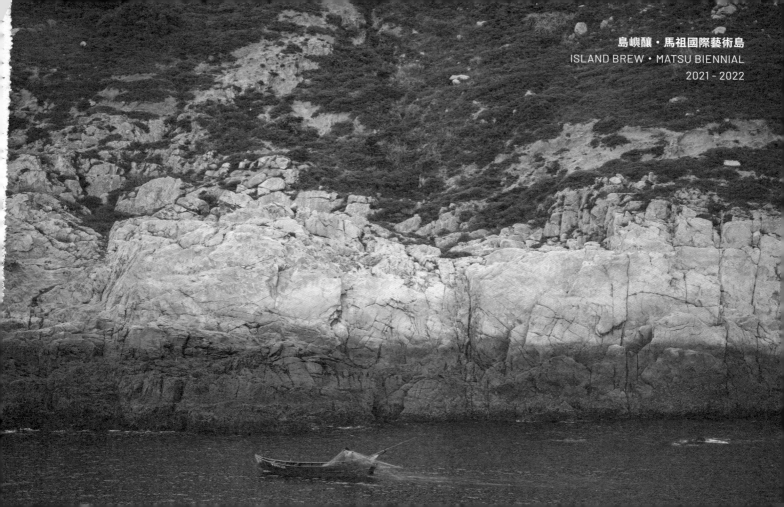

展望未來十年的島嶼轉身
Envisioning the islands' transformation in the next ten years

馬祖國際藝術島
Matsu Biennial

解除戰地政務 30 年後的馬祖，正展望下個 10 年的島嶼轉身；以「馬祖國際藝術島」為政策主軸，希望透過藝術引路，偕以教育、建築、設計為多方切入軸線，共同梳理與催化這場發酵。

　　首屆馬祖國際藝術島以「島嶼釀」為策展題目，將於 2022 年 2 月 12 日至 4 月 10 日在四鄉五島展開，邀請觀者一同翻轉視角——昔日從海上定位馬祖，如今透過觀海景框由內而外辯證島嶼，探照島嶼轉身的更多可能。

Thirty years after the dissolution of the war zone administration, Matsu looks forward to its transformation in the next decade.The Matsu Biennial, proposed as a strategy for the island's regeneration, aims to brew the future through education, architecture, and design, with art being the yeast.

Curated under the title *Island Brew*, the inaugural Matsu Biennial will be held from February 12 through April 10, 2022 in four villages across the five islands of Matsu. With a renewed perspective from the inside out - from viewing Matsu through the telescope of the sea to contextualizing the islands through the sea-viewing frame on the island - we invite the audience to explore the possibilities of the islands' transformation.

世代共釀的島嶼風味
An island flavor brewed for generations

首屆策展主題：島嶼釀
The inaugural curatorial concept of Matsu Biennial : Island Brew

首屆策展主題島嶼釀，以一扇扇觀海景框作為登島識讀馬祖的請帖，邀請你參與遠至而來的風與在地沃土的交會，也邀請你從多元視角填入觀點激盪，一同醞釀島嶼的轉身。

馬祖位處臺灣海峽正北方、面臨閩江口，也是黑潮支流與親潮的交會點，曾因豐富漁獲作為海洋貿易繁榮之所，也因明清海禁與遷界而成為漁人流離之地。民初動盪，日軍、國軍、閩海梟雄勢力據此明爭暗鬥；戰地政務時期全島軍民一體，國防方針決定了 36 年的島嶼樣貌。

立足汪洋環繞的島嶼、身處政治板塊碰撞的前沿，天氣決定了船舶和飛機能否航行，也分配了餐桌上罐頭與鮮食的比例；軍管時期的宵禁、燈火、電器等諸多管制政策，決定了出門、關窗的時段，甚至煮飯洗衣的方式、運動的種類。在不知道什麼時候能再見的日常裡，島民用謙卑與未知相伴生活，以虔誠信仰安放自己和家人，因為珍視每份得來不易而更炙熱地守護家鄉，更堅毅勤奮地工作、養育，寄託於務實，盡全力後等待。

這是時代刻畫下的島嶼，有順應亦有韌性，同時孕育馬祖深厚文化底蘊，在戰地政務終止後吸引各方專業者如風一般相繼登島，與在地世代共同以馬祖的語言、飲食、信仰、祭典、聚落和戰地景觀為陳年基底，風土交會將光與暗、戰爭與和平、開放與封閉等極端質地並陳，釀造獨具魅力的島嶼風味。

The *Island Brew* sends an invitation to see Matsu through a series of sea-viewing frames. We invite you to participate in the encounter between the wind from afar and the fertile local soil, to draw inspiration from diverse perspectives, and, together, to brew the islands' transformation.

Located directly north of the Taiwan Strait and facing the mouth of the Min River, Matsu is the intersecting point of the Kuroshio tributary and Oyashio currents. It was a prosperous place for marine trade with its rich catches, and it was also the place of exile for fishermen owing to the maritime ban and boundary delimitation during the Ming and Qing dynasties. During the turmoil of the early era of the Republic of China, the Japanese army, the Nationalist army, and the Minhai warlords fought over the islands. During the period of war administration, the entire island was united with the military, and the national defense policy determined the islands' appearance for 36 years.

Surrounded by the ocean, the islands lay at the meeting point of political tectonic plates. The weather determined whether boats and planes could travel and whether canned or fresh food graced the dining table. The curfew, lights, and electrical appliances of the military administration period also dictated when people could leave their homes, when to close the windows, how daily chores were performed, and the type of exercise allowed. In a time when meeting again was no longer certain, the islanders humbly lived with the unknown, resting themselves and their families on devotion and faith, guarding their homeland passionately because they cherished every part of it, working and raising children with more determination and diligence, putting their trust in pragmatism, and waiting after their best exertions.

This is an island, carved by the times, that is both compliant and resilient, and these encounters nurtured Matsu's profound cultural heritage. After the termination of the war zone administration, professionals from many disciplines were drawn like the wind to the island, and, together with generations of locals, they use Matsu's language, food, beliefs, rituals, settlements, and battlefield landscapes as an ancient foundation, juxtaposing the extremes of light and darkness, war and peace, and openness and closedness in the interactions between foreign and local, brewing a unique and charming island flavor.

Contents

依海之境：島嶼攝影誌
A Land by the Sea

攝影師 ——— 林科呈

國立臺北藝術大學藝管所畢，目前為眼福映像工作室負責人，
2017 獲得 Iphone IPPA 手機攝影大獎 Honorable Mention，
擅長拍攝類別為表演藝術、人文紀實，作品常見於 GQ
Taiwan、Vogue Taiwn 等雜誌。

Photographer ——— James Lin

With a degree from the Graduate Institute of Arts Administration and
Management at Taipei National University of the Arts, James Lin is
currently director of the Yenfu Photography Studio. Lin received an
honorable mention from the iPhone Photography Awards in 2017, and his
work is often seen in magazines such as GQ Taiwan and Vogue Taiwan
with a specialty in performing arts and documentary photography.

透過拍攝馬祖列島當中五座主要生活島嶼
的人文、祭儀、風景，抓取在地生活的片
刻，展現每一座島目前的位置與功能⋯⋯

Capturing moments of daily life, the customs, and
scenery on the five major islands of Matsu, these
photographs reveal the unique locations and
functions of each place.

東莒地圖

Dongju Map

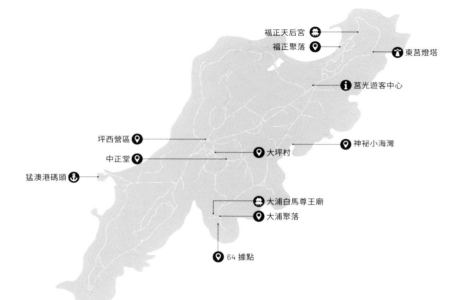

福正天后宮

福正聚落

東莒燈塔

莒光遊客中心

坪西營區

大坪村

神祕小海灣

中正堂

猛澳港碼頭

大浦白馬尊王廟

大浦聚落

64 據點

東莒：
拾貝人基地

Dongju:
The Base of the Shellfish
Collectors

距離南竿航程 50 分鐘的東莒，可以看見最深最長的一道藍眼淚，也就是海浪順著潮水聲整齊地拍打沙灘，浪花總在淺藍波峰後拉出一條深藍曲線。

要看藍眼淚需要滿足幾項條件，坡度緩、開口長是必備的地形，福正沙灘完全滿足這些描述。東莒是座平緩的島，走路不會氣喘吁吁的島，一座安安靜靜的島。浪總緩緩地打在東莒沙灘上，在彎彎淺淺的澳口上，散落著大小不一的石頭；這些石頭中包裹著石塊，毫無縫隙地鑲嵌著彼此。東莒島以東洋山為界，北面的火山角礫岩與南面的花崗岩疊合，形成一緩一陡、細緻與粗獷的格局。

海岸礁石上面爬滿藤壺與石鱉，剛退去的潮水形成不適合人行的水窟，益發濕潤。在會刺痛的稜角中，經過一重又一重的岩石中跳上跳下，經常能看見退潮後的東莒海邊充滿著討礁（thǒ-la，拾貝）的人們。他們是平地的登山者，身後肩背著長及腰部的小竹簍，沿路彎腰，抄著自製的鐵柄、圓鍬，在如山一般的大石屏障後忽隱忽現，尋找石縫中的美味；只見他們一步步在崎嶇隆起間飛跳，熟門熟路往海走去，一叢叢石縫中的蚶団（kàng-ngīang，紫孔雀蛤）用蛤扒（kak-pà，勾螺貝工具）挖起，蚶団之後，還有筆架（pik-kǎ，佛手）。一位討礁的（thǒ-la-ǐ，拾貝者）說具有奇特形狀是筆架狡猾之處，當遊客不知道如何對煮熟的筆架下手時，在地導遊都很高興代勞祭祀他們的五臟廟。

有時能在東莒往南竿的船班上看著一位位依伯、依姆，提著一箱箱漁獲，或笑著手握一把把在地特產麥蔥走出船艙。東莒人的冰箱是大海，而東莒的海不只是東莒人的，更是真正馬祖島民的海上農田。

面積／平方公里 [*1]
Area / km²

2.64

莒光鄉人口數／人 [*2]
Total Population / Persons

1,490 (326 戶)

The deepest and longest wave of "blue tears" (noctiluca scintillans) can be seen in Dongju, 50 minutes from Nangan, where the waves lap against the beach with the sound of the tide, always drawing a dark blue curve behind the light blue crest.

There are several criteria that must be met to produce the blue tears, including terrain with a gentle slope and a long opening. Fuzheng Beach satisfies all these criteria. Dongju is a gentle island, an island where you can walk without panting, and a quiet and peaceful island; the waves always strike Dongju Beach gently. Rocks of various sizes are scattered on the curved and shallow inlets of the island, wrapped in gravels that are embedded with each other without any gaps. Dongju Island is bounded by Mt. Dongyang, and the volcanic conglomerate in the north and the granites in the south overlap, forming a contrasting pattern of shallow and steep, delicate and rough.

The reefs along the coast are covered with barnacles and chitons, and the receding tides leave tide pools that are not suitable for walking, keeping the area wet. In the sharp angles of the rocks, you often see people *thǒ-la* (shellfish collecting) at the edge of the Dongju Sea at low tide, jumping from one rock to another. They are flatland hikers, carrying small, torso-length bamboo baskets on their shoulders, bending down on the paths, holding their homemade shovels and spades and working behind boulders in search of ocean delicacies in the crevices. As they hop across the rugged surface, skillfully moving toward the sea, they dig up *kàng-ngīang* (a purplish bifurcated mussel) and *pik-kǎ* (stalked barnacle) from the crevices of the rocks. A *thǒ-la-ǐ* explains that *pik-kǎ* are cunning in their odd shapes, and, when tourists cannot figure out how to work their way into cooked *pik-kǎ*, the local tour guides are more than happy to sacrifice these barnacles to their belly temples.

Sometimes, you can see many local islanders on the boat trip from Dongju to Nangan, each emerging from the boat cabin with boxes of fish or smiling with a handful of the local specialty - bunching onions - in their hands. The Dongju people's refrigerator is the sea, but the sea in Dongju does not belong only to the Dongju people. It is, in fact, an ocean farmland for all Matsu Islanders.

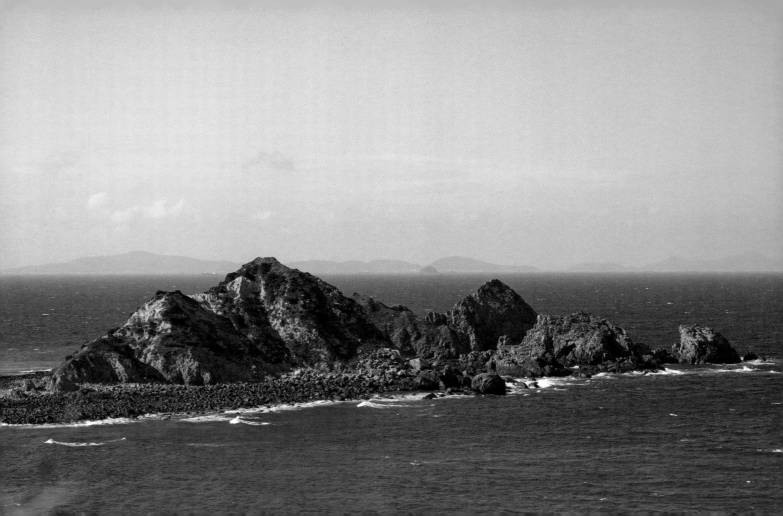

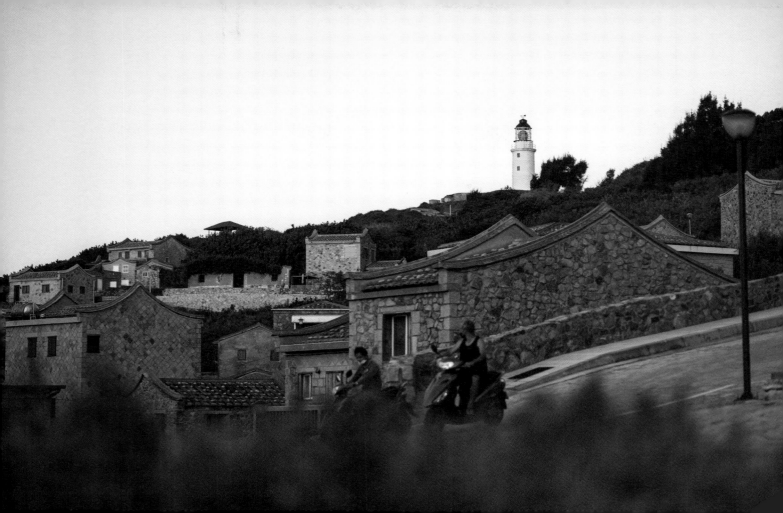

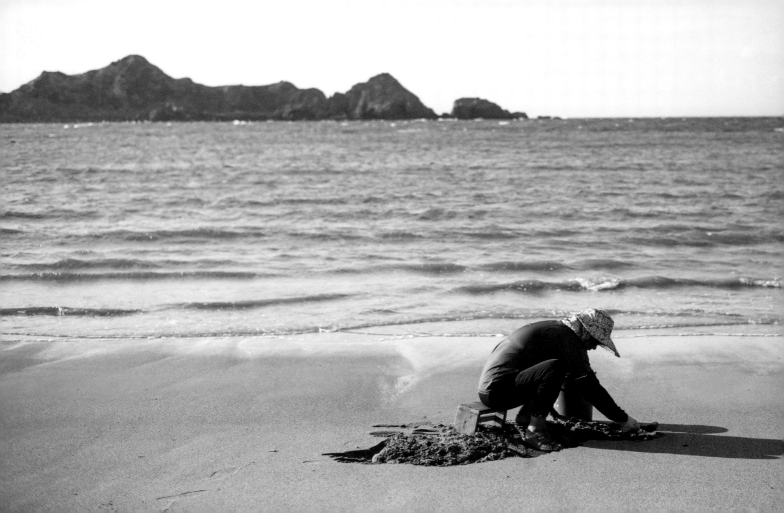

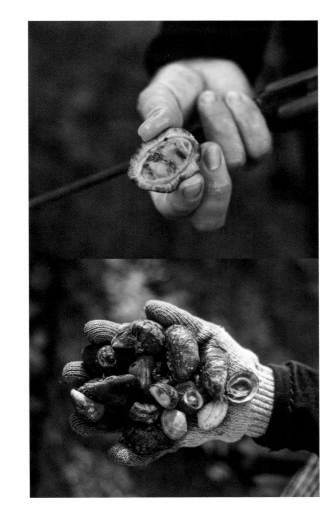

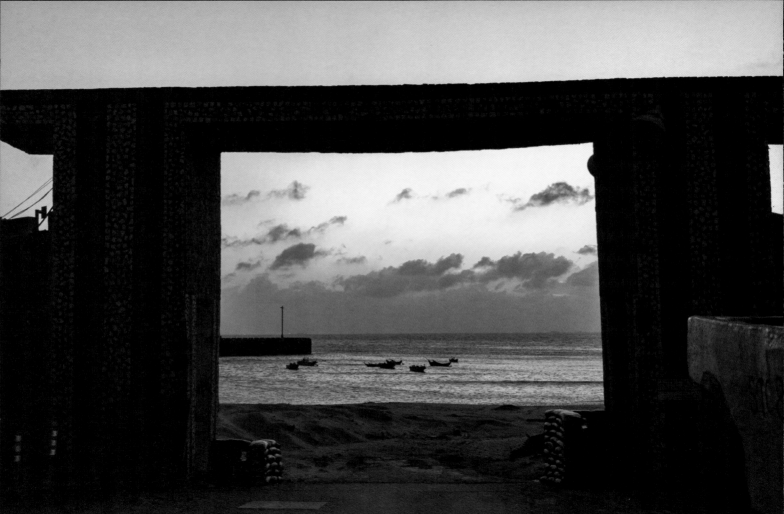

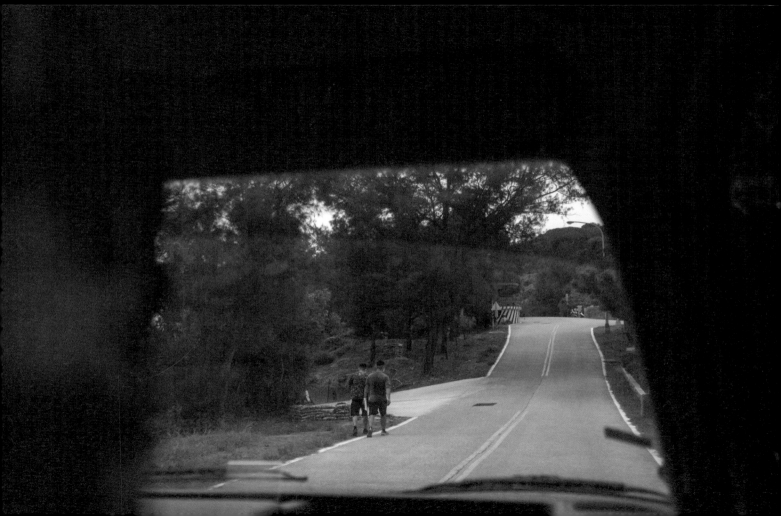

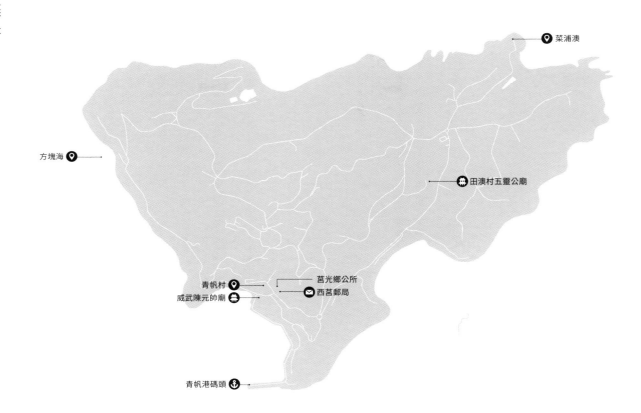

Xiju Map
西莒地圖

菜浦澳

方塊海

田澳村五靈公廟

莒光鄉公所
青帆村
西莒郵局
威武陳元帥廟

青帆港碼頭

本圖為示意圖，非實際比例圖 This map is not to scale.

西莒：
駐守的回憶

Xiju:
Memories of the Military
Service

西莒位於交通要道，是船隻進入閩江前的候潮之地，與東莒同樣距離南竿 50 分鐘。早在 18 世紀英國人調查中，被稱作「白犬」（White Dog）的西莒就已經是重要座標。相傳一片裸露在海上反射成白色的岩石，使它得到此名。

中法戰爭時期，法軍轉戰基隆前鐵甲船曾在此停泊。船還沒停靠碼頭，山城的格局已經顯露。這裡是過去居民口中的小香港，國軍建造的國宅平房還刻著「救總」（中華救助總會）的落款，一排白房子中錯落著水綠色的木板門，是海邊舢版漆剩塗料，居民物盡其用的表現。

無論在青帆、田澳還是西路，整座西莒是靜止沉睡的島嶼。「特製綿綿冰」、「各式酒菜」、「電話叫貨」，斑駁的招牌還留著七〇年代的廣告字型，招攬老兵回憶。仍在營業的商店，店內陳設則是這樣的：木紋貼皮、略顯復古的合菜圓盤桌上可能沾了一點上個客人留下來的番茄醬，旁邊擺著一小包隨手抽衛生紙，廁所在樓上陽台到底處，加上塑膠門就是與世隔絕的聽雨軒。樓下老闆娘正看著電視，身旁還有幾台不再有阿兵哥包台的電腦，價目表不再更新，只剩冰櫃內的飲料零食還繼續服務著官兵。

「你知道嗎？這裡阿兵哥以前可多著呢！」一間複合式經營商店的老闆娘這樣說。遊客宛如過去馬祖的五萬大兵，每年新兵不斷報到，新的面孔、新的人。老闆卻跟阿兵哥一樣，永遠笑著，不曾老去。他們服務著一代又一代的阿兵哥──從能成為老公到已經能當孫子輩的阿兵哥。有些房子改建了，有些房子在大火中付之一炬，有些西莒的房子戍守著生意，就跟那些站哨的阿兵哥一樣。居民站在自己的家園，不曾離開這片土地。

面積／平方公里 [*1]	2.37	莒光鄉人口數／人 [*2]	1,490 (326 戶)
Area / km²		Total Population / Persons	

Xiju is located somewhere along the main traffic route, where ships wait for the tide before entering the Min River. It is 50 minutes from Nangan, as is Dongju. As early as the 18th-century British survey, Xiju, known as "White Dog," was already an important landmark. According to legend, the name derives from a series of whites rocks exposed in the sea.

During the Sino-French War, the French military docked here before they turned to battle in Keelung. Before a ship docks at the pier, the structure of the mountain town is already revealed. It is known to the older residents as "Little Hong Kong." The bungalows built by the Nationalist Army are still marked with the name of the Free China Relief Association (FCRA, now known as CARES, or Chinese Association for Relief and Ensuing Services), and the rows of white houses feature aquamarine wooden doors, the color of leftover paint from the sampans at the seaside, a sign that the residents make the best use of what they have.

Whether in Qingfan, Tian'ao, or Xilu, all of Xiju is an island in slumber. The aged signboards still display advertisements from the 1970s - "Custom Shaved Ice," "Variety of Dishes," and "Order by Phone" - inspiring memories of veterans. The décor of the stores that are still in business may include an old round table whose wood veneer is splashed with the ketchup of a previous customer, a small packet of tissue paper beside it. The bathroom is at the end of the patio upstairs, with a plastic door isolating it from rest of the world. The owner watches TV downstairs amidst a few computers that soldiers are no longer paying to use, and the price list is no longer updated; only the drinks and snacks in the cooler are still served to officers.

"Did you know? There used to be a lot of soldiers here," says the owner of a mart. Tourists are like the 50,000 soldiers once stationed in Matsu, with new recruits arriving every year, but the owners, like the soldiers, are always smiling and never grow old. They have served generations of soldiers, from those who have become husbands to those who could be their grandchildren.Some Xiju houses were remodeled, some Xiju houses were burned in the fire, and some Xiju houses continue their business, just like the soldiers who stand guard. The inhabitants continue to live in their houses and have never left their home.

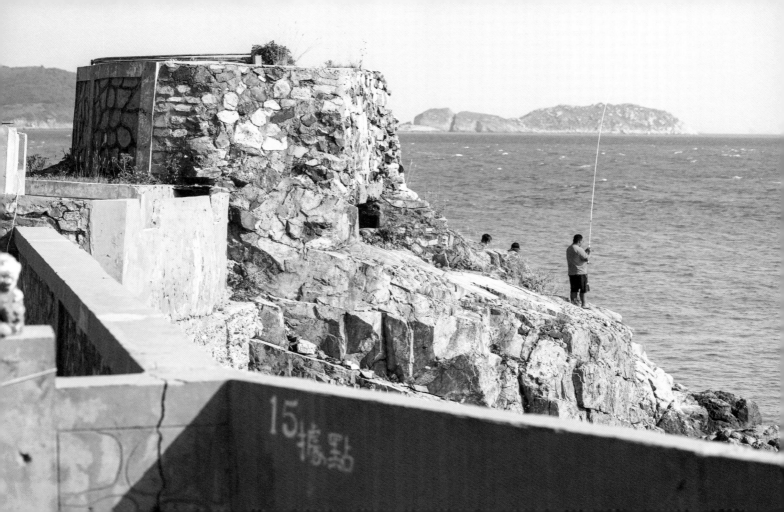

南竿地圖
Nangan Map

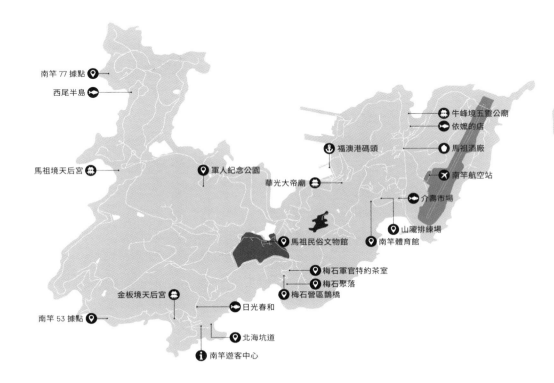

南竿 77 據點

西尾半島

馬祖境天后宮

軍人紀念公園

華光大帝廟

福澳港碼頭

牛峰境五靈公廟

依嬤的店

馬祖酒廠

南竿航空站

介壽市場

山隴排練場

南竿體育館

馬祖民俗文物館

梅石軍官特約茶室

梅石聚落

梅石營區鵲橋

金板境天后宮

日光春和

南竿 53 據點

北海坑道

南竿遊客中心

南竿：
人際網絡中心

Nangan:
A Social Network Center

南竿，因為以前島上竿草遍布得名。這座島嶼是連結馬祖列島的轉運站，從牛角到西尾──有人說這些村落的名稱來自於整座南竿島就像一頭牛橫躺在閩江口上。又相傳媽祖屍身漂流至此，日本人用了南竿「馬祖澳」的澳口名稱，命名整座島嶼，馬祖這個名稱才在此傳開，成為島嶼的名稱，也成為列島的代稱。以南竿為轉運中心，到北竿 15 分鐘、到莒光 50 分鐘、到東引 2 小時、到台北 50 分鐘，在飛機與船之間不斷轉換，南竿就是旅人在馬祖上天下海，公車、輪船、飛機陸海空三合一的綜合境界。

南竿也是閩江口的中心。從二戰期間開始，就是閩海屏障的大門，林義和在此稱霸，建立司令部、部屬公館、兵工廠，控制周遭近十座島嶼。今天的南竿，仍是四鄉五島的縣政府所在地，還是馬祖唯一的星巴克、八方雲集所在地。南竿就是極致風潮的展現，最快速流行的事物總是在南竿發生，從茶壺藝品、唱片行、鐘錶行到特產店，還有許多卡拉 OK。在一戶戶家庭的炸雞、鐵板麵與啤酒中，最精采的馬祖夜生活也在此展開。

南竿島不僅是政經中心，也是人際網絡的交換中心。馬祖人如果沒有念過島上的馬祖高中，不會認識來自其他島嶼的同輩島民。當五島同學一起坐在教室，三年的革命感情在此大雜燴，也奠定以後工作事業人脈的基礎。南竿就是馬祖資源的集中地；馬祖的繁華，馬祖的一切，海的起點，都從南竿開始。

面積／平方公里 [1]
Area / km²

10.4

南竿鄉人口數／人 [2]
Total Population / Persons

7,629 (1,988 戶)

Nangan Township, a transit point connecting the Matsu Islands, is named after the gan (miscanthus) that once spread across the island. From Niujiao (Bullhorn) to Xiwei (West Tail), some say that the names of the island's villages reflect Nangan's resemblance to a bull lying across the mouth of the Min River. Some also say that it was the Japanese in Nangan who adopted *Matsu-ao* - the name of the bay in which, according to legend, the corpse of the Chinese sea goddess Mazu was found - as the name of the entire island, so that Matsu became the accepted toponym for not only the island but also the archipelago. With Nangan as the transfer center, it takes 15 minutes to travel to Beigan, 50 minutes to Chukuang, 2 hours to Dongyin, and 50 minutes to Taipei. Frequently switching between planes and boats, tourists in Nangan have the full experience of traveling by bus on land, boats in the sea, and planes in the air while coming to Matsu.

Nangan is also the center of the Min River estuary and, since World War II, the gateway to the Min Sea Barrier. Lin Yi-he once dominated the area, establishing his own command headquarters, military dormitories, and an arsenal that controlled nearly a dozen islands in the region. Today, Nangan is still the seat of the county government among the four villages and five islands of Matsu, and it is also the site of businesses such as Starbucks and Bafang Dumpling. Nangan is the trendy city in Matsu, where the novel and popular things are found: tea crafts, record shops, watch stores, specialty stores, and a variety of karaoke bars. The most exciting Matsu nightlife starts here, with fried chicken, teppanyaki noodles, and beer served in every household.

Nangan Island is not only a political and economic center but also a hub for networking. A Matsu resident who did not attend Matsu High School would not meet peers from the other islands; the camaraderie built in three years with classmates from all the five islands of Matsu lays the foundation for future work and career contacts. In this sense, Nangan becomes the hub of resources in Matsu. The prosperity and every other aspect of Matsu, like the ocean voyage, begins in Nangan.

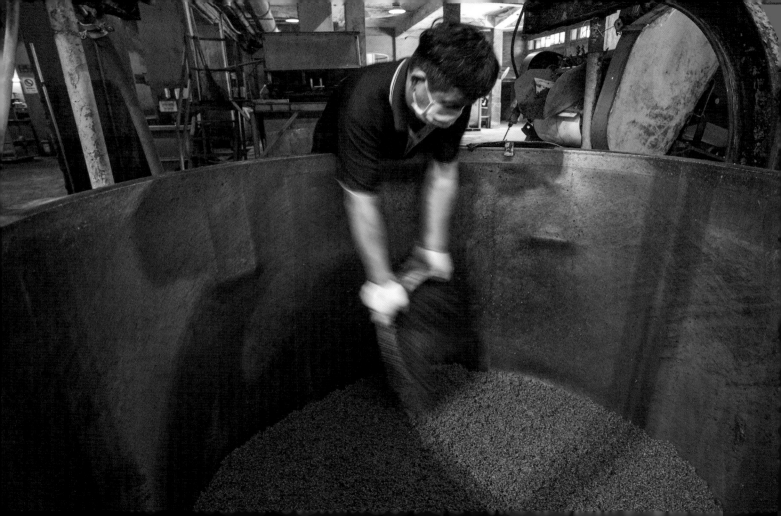

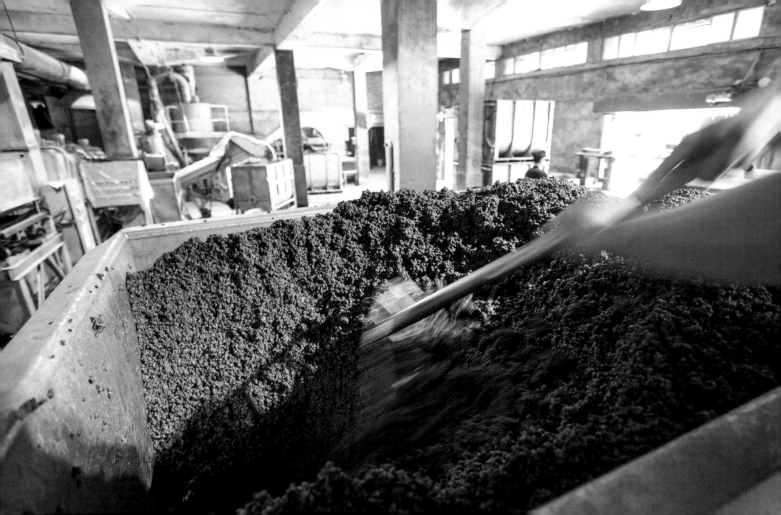

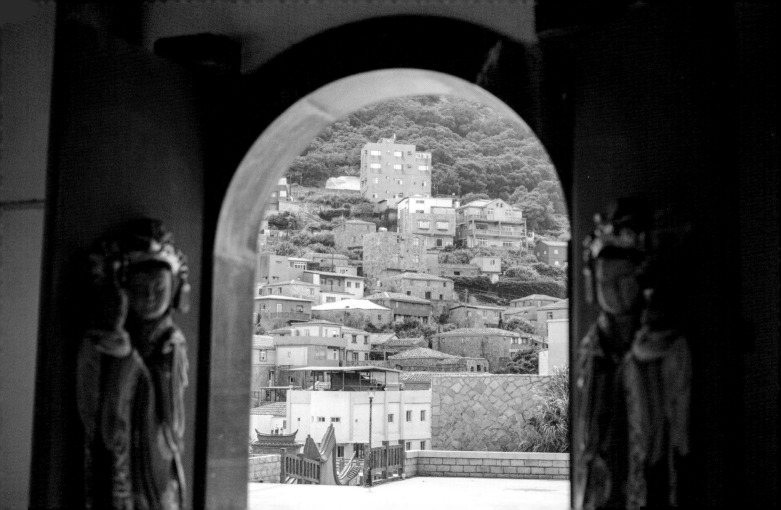

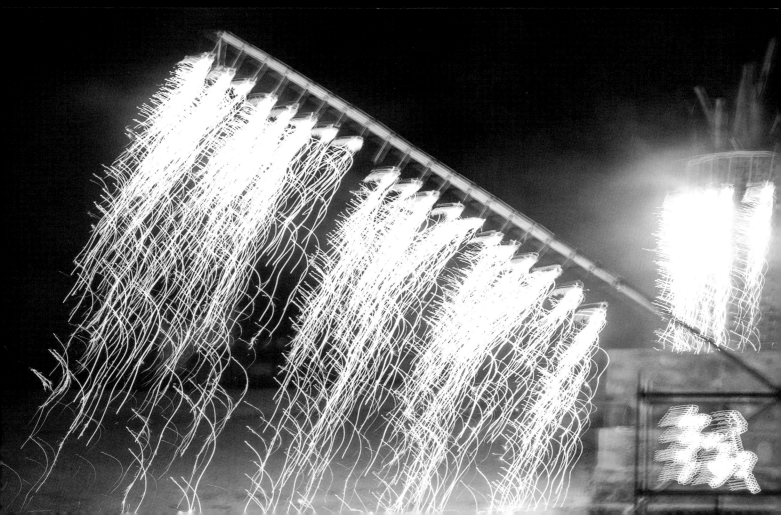

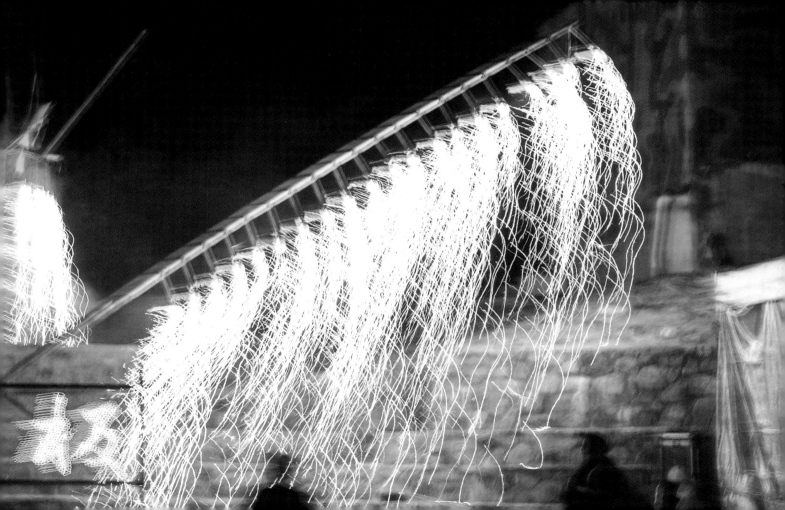

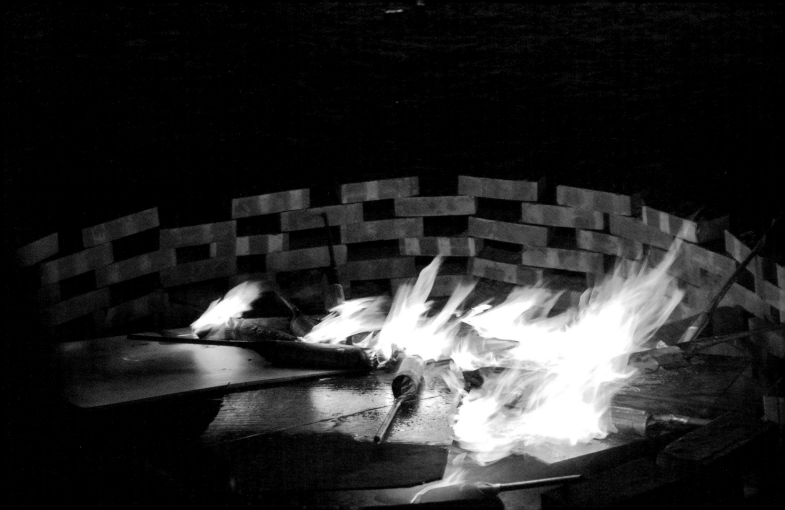

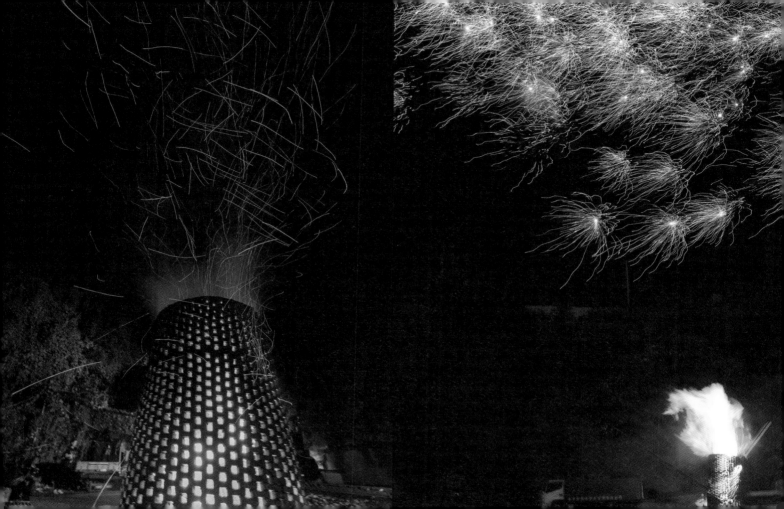

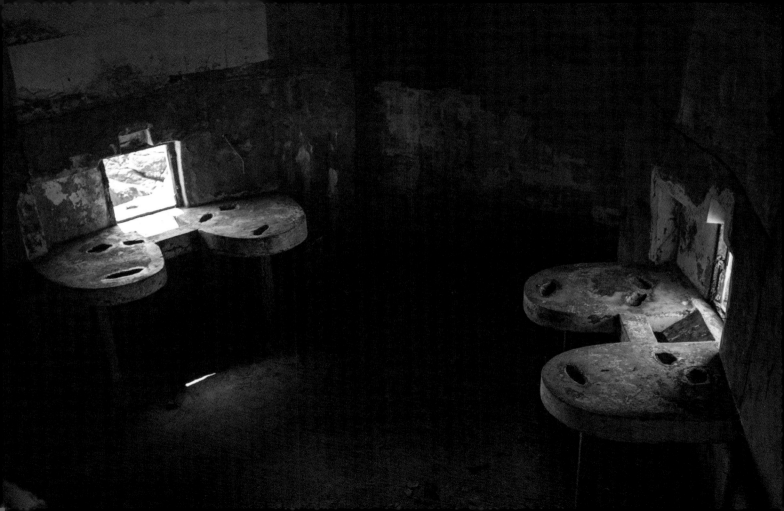

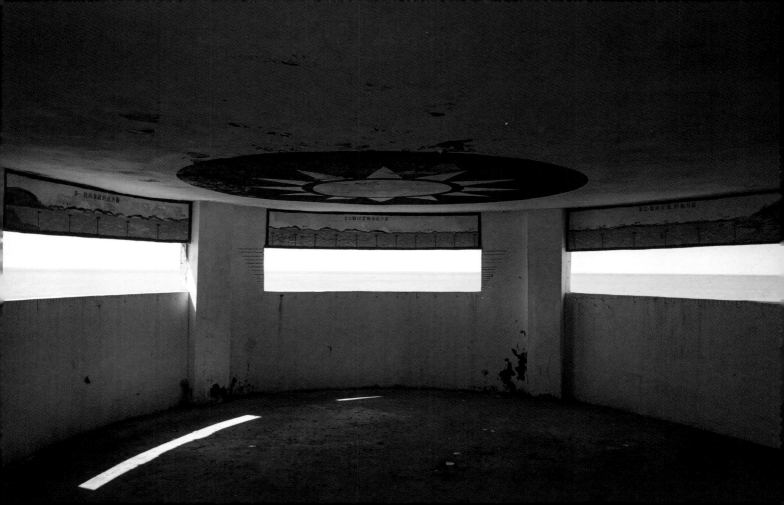

北竿地圖
Beigan Map

亮島

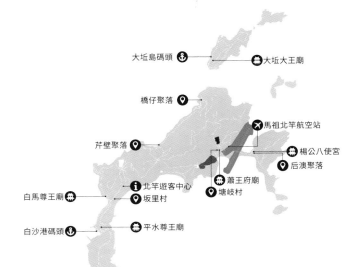

大坵島碼頭 ⚓ → 🏯 大坵大王廟

橋仔聚落 📍

芹壁聚落 📍

✈ 馬祖北竿航空站

🏯 楊公八使宮

📍 后澳聚落

ℹ 北竿遊客中心

🏯 蕭王府廟

白馬尊王廟 🏯 → 📍 坂里村

📍 塘岐村

白沙港碼頭 ⚓ → 🏯 平水尊王廟

本圖為示意圖，並非實際比例圖 This map is not to scale.

北竿：
與神生活

Beigan:
Living with the Gods

距離南竿 15 分鐘船程，隔著海峽望去的北竿是海之涯、山之巔，馬祖最高的所在。北竿因人而興、因廟而靈，是上天厚賜的島嶼，秋冬螃蟹、白鱙滿地金，在這座距離中國最近的島嶼，從過去漁業時代就有直通對岸黃岐的黃岐渡（Uong-ngie-tôu）舢舨客輪。兩岸交流帶來漁獲，也帶來詩詞與文明。「告訴你以前怎麼打網的！」一位打魚依伯這樣說，一邊在他「好啊！利啊！過了一蜀啊！」的吟唱中，北竿漁民打樁下網捕魚的記憶，依然流傳在這漁船仍然興盛的島嶼。

　　「小時候，老師跟我們開玩笑說，壁山有多高？ 29,800 公分。」一位導遊這樣說著從小記到現在的冷笑話。從壁山下切，山稜化做七村八澳的北竿島：每個村、每個澳口都有自己的守護神。北竿人以扛乩與神明溝通，神明在村子重要的歲時祭儀時刻降旨，當四位扛著轎子的乩骹（kiu-kha，轎將）隨著轎共同不由自主地舞動，舞步調和出圓弧落在八仙桌上，每個敲擊頓點與前進後退，都成為桌頭（touh-làu，解讀神明旨意的人）判斷神明旨意的重要依據。

　　擺暝（pě-màng，元宵祭神、酬神儀式）不僅是神明出巡的日子，也是全村不論在地還是移居外地村民大團圓，一起替神明做鬧熱的日子。這天北竿各廟信眾晚上會食福（sièk-hóuk，共同享用答謝神明的食物），接著請神明指示來年風水。「眾人聽命！元帥指示：明年宮廟交流暫停，眾人勿出遠門！」早在兩年前的食福後，扛乩始祖蕭王府的廟主委就大喊著神明的旨意，預告了當前疫情的流行。北竿神明職能多元，從看病到護幼無所不包，還有抓鬼揹背的故事。雖然很多「神明之間的事」屬於不能為外人道的禁忌，但在大人故意拉低聲量，用閩東語說著悄悄話時，早已進入每個豎耳細聽的北竿小孩腦海裡。

面積／平方公里 [*1]
Area / km²

9.9

北竿鄉人口數／人 [*2]
Total Population / Persons

2,974 (841 戶)

15 minutes by boat from Nangan on the other side of the strait, Beigan snuggles against the sea while accommodating the highest point of Matsu. Beigan is prosperous because of its people, and religious because of its temples. It is an island favored by the gods, where crabs and white poms are abundant in fall and winter. In the old fishing days, passenger sampans (*Uong-ngie-tôu*) travelled between Huangqi in China and the island, bringing catches from the sea as well as poetry and civilization. "I'll tell you how the nets were cast!" says an old man who fishes. He sings, "Great! Brilliant! A one has gone by," evoking memories of fishermen from Beigan casting and anchoring nets for fish on this island, where fishing boats still thrive.

"When we were little, our teachers joked with us about the height of Mount Bi. It is 29,800 cm." A tour guide tells this childhood anecdote. The ridge of Mount Bi descends to the island of Beigan, whose seven villages and eight harbors each has its own guardian deity. Beiganers communicate with the gods by means of a divination chair ritual. When the gods announce their wishes during the village's annual ritual, four *kiu-kha* (shamans) dance involuntarily while carrying a palanquin, harmonizing their steps toward the arcs of the square table. Each strike, each pause, each forward and backward movement becomes an important auspice with which the *touh-làu* (the interpreters of the gods) interpret the gods' commands.

Pě-màng (the ceremony of the gods at lantern festival) is not only a day for the gods to go on parade but also an opportunity for the whole community, both local and migrant villagers, to reunite and celebrate to please the gods. On this day, the followers of all the temples in Beigan have a *sièk-hóuk* (members of a temple enjoying the food for the gods) in the evening and then ask the gods to guide them on the feng shui (fortune) of the coming year. As early as two years ago, after the reunion meal, the temple commissioner of Xiao Wangfu, the originator of the mediumship, announced the will of the gods: "All listen to the orders! The Marshal instructs that next year's temple exchange will be suspended, so don't travel far away from home," foretelling the current pandemic. The gods of Beigan serve a wide range of functions, from watching over the sick to nursing the young, or even capturing ghosts to scratch the back for people. Although many of the "matters between the gods" are taboo, they have already entered the minds of the Beigan children who are eager to listen while the adults deliberately lower their voices and whisper in the Matsu language.

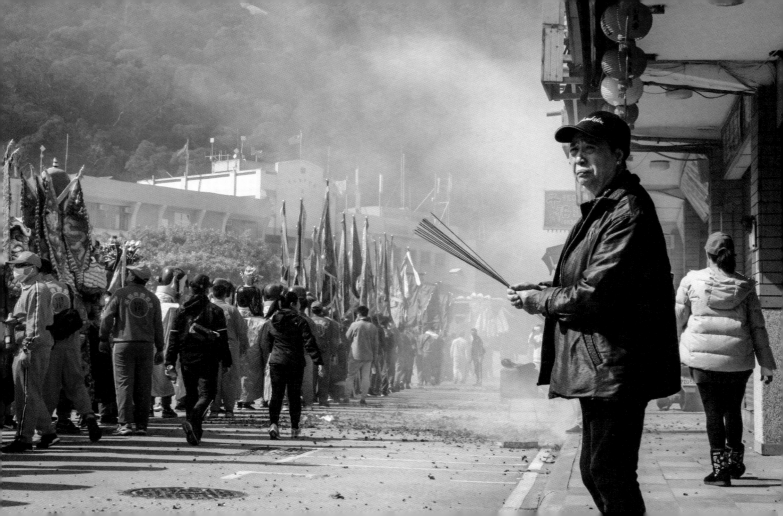

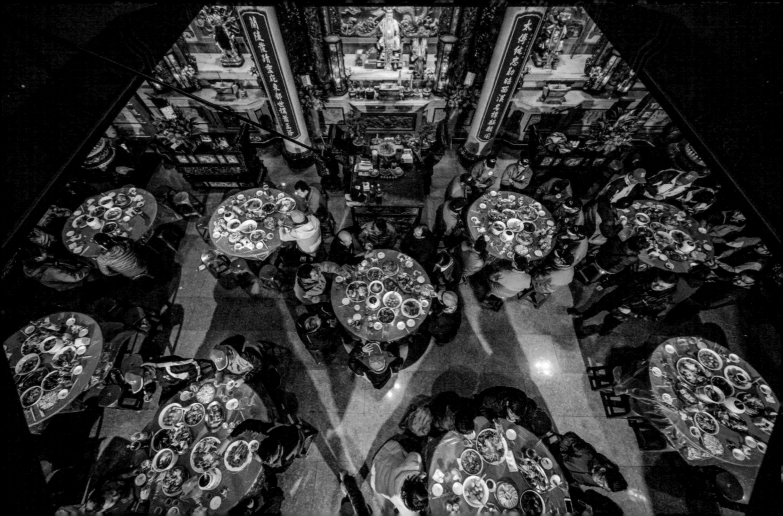

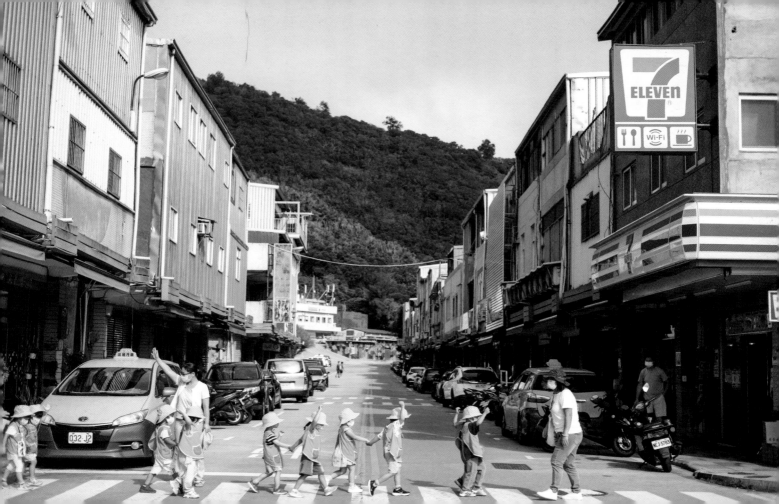

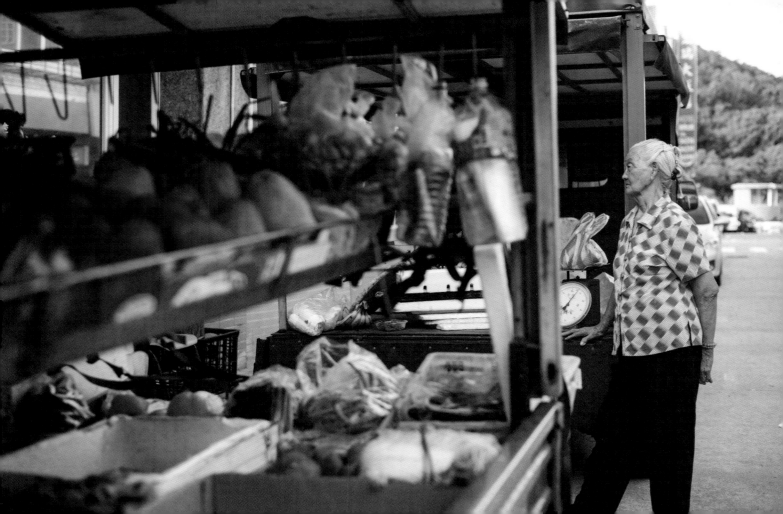

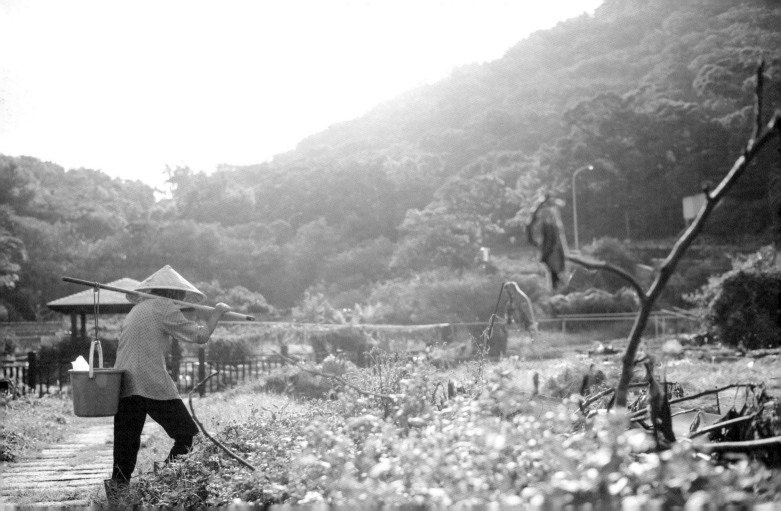

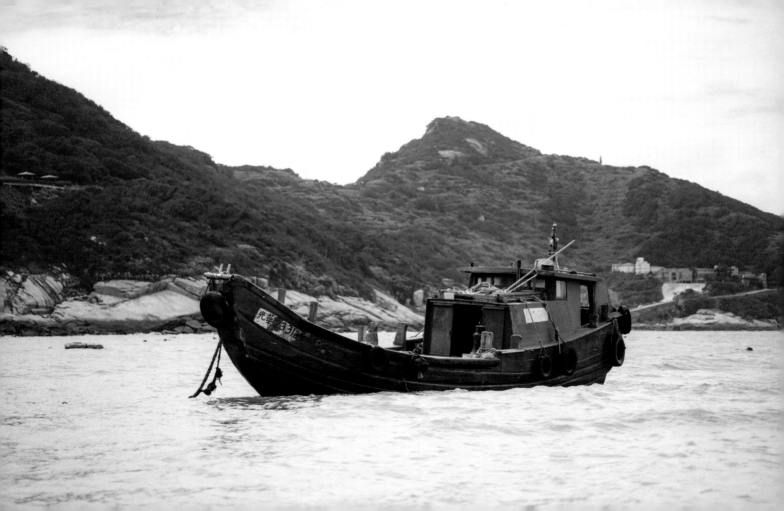

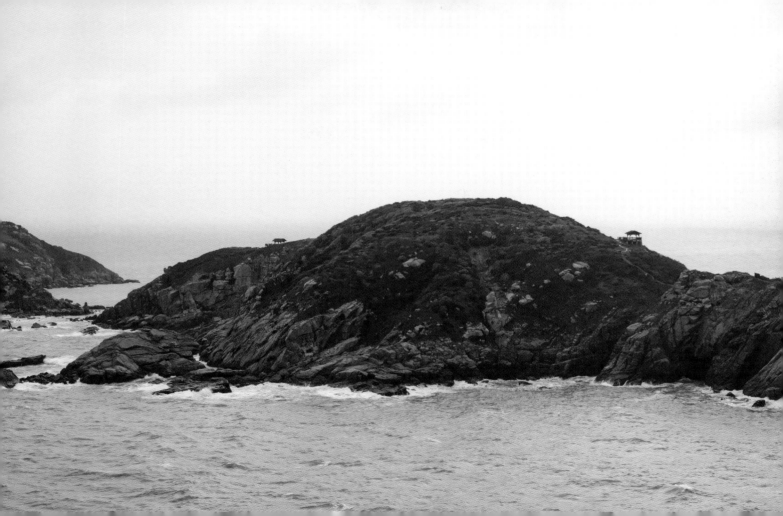

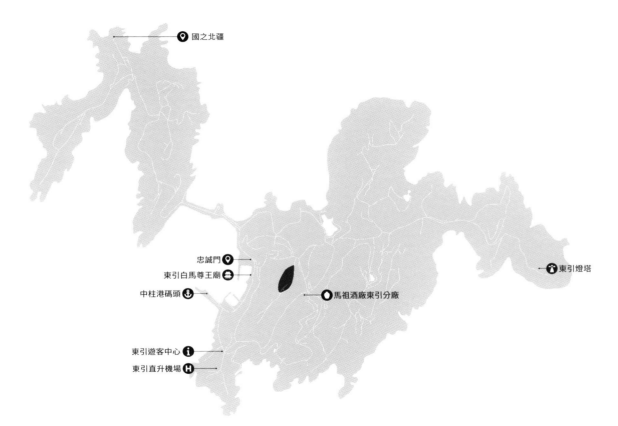

東引地圖 Dongyin Map

國之北疆

忠誠門

東引白馬尊王廟

中柱港碼頭

馬祖酒廠東引分廠

東引燈塔

東引遊客中心

東引直升機場

東引：
海峽之巔

Dongyin:
The Peak of the Strait

東引距離南竿 2 小時船程；距離基隆 8 小時船程；在 1994 年北竿的飛機場開通前，東引遠比馬祖其他島嶼能夠更快地與世界相連結。一座軍人比島民多的島嶼，一座台灣釣客比例居馬祖之冠的島嶼，東引是軍民一家、是釣客天堂。在這座島上，閩東語、閩南語、客家語和阿兵哥的操練聲高度混雜，融合成東引特有的複調。

東引是沒有沙灘的島嶼，在島嶼特有種生物出沒的夏季，野芒花（iǎ-mang-ngua，紅藍石蒜）與蟹魯魯（hǎ-lū-lū，南海溪蟹）生存在山坡與水田間，與當年阿兵哥造林手植的木麻黃、相思、苦楝共生息。但更多時候，東引只有草叢，遮擋島嶼掩蓋不住的壯麗山形地勢。這些山頭組合起來，從南竿前往的海上看去，成了耆老口中的東引島另一座別稱——「七星山」（tshǐk-ling-lang）。

「東引人在外不怕承認自己是東引人。」一位在地出身的老師這樣說。在這裡，地址直接寫上「東引鄉〇號」，連縣名與村名都省略了。在人口集中於南澳的東引，人們也與聚居形態一樣團結。東引人的自信，在每天一艘的船班駛回南竿後開始：東引島成為獨立的島嶼，鄉長就是島主，華麗轉身成一座偏安東海上的王國。

在臺馬輪鳴了汽笛的船塢中，從南竿下船的馬祖人來來去去，遊客也來來去去，但東引島依舊驕傲地存在，在蔚藍的海水環繞間，不斷拍打說著東引人自己的故事。

面積／平方公里 [*1]
Area / km²

4.4

東引鄉人口數／人 [*2]
Total Population / Persons

1,484 (357 戶)

Dongyin is a two-hours boat ride from Nangan and a eight-hours boat ride from Keelung. Before the opening of Beigan's airport in 1994, Dongyin was able to connect to the world far more quickly than any other island in Matsu. The island has more military personnel than islanders and the highest percentage of Taiwanese anglers in Matsu. Dongyin, home to both military and civilians, is an island of beaches and a paradise to anglers. On this island, the languages of Fuzhou, Minnan, Hakka, and military drills blend in the unique polyphony of Dongyin.

In summer, the island's unique species emerge. *lǎ-mang-ngua* (**Lycoris haywardii Traub**) and *hǎ-lū-lū* (**Nanhaipotamon formosanum**) are found on the mountain slopes and in the paddy fields, respectively, coexisting with the ironwoods, Taiwan acacias, and chinaberries that were planted by soldiers. Generally, however, grasses cover Dongyin as though attempting to conceal the magnificent mountain terrain of the island. Due to the appearance of these hills as viewed from the sea of Nangan, the elders gave Dongyin the byname of *Tshĭk-ling-lang* (Seven Star Mountain).

"The people of Dongyin are not afraid to admit that they are Dongyiners," says a teacher from the area. Here, the address is written simply as "Dongyin Township No. __ ," and the names of the county and village are omitted. In Dongyin, where the population is concentrated in Nan'ao, the people are as closely united as their settlement. The Dongyiners' self-confidence emerges after the boat makes its daily return to Nangan: Dongyin Island is an independent land, a gorgeous, remote kingdom on the East China Sea, and the village chief is the king of the island.

At the dock where the *Taima Ferry* sounds its horn, Matsu people come and go as they disembark from Nangan. The tourists come and go as well, but Dongyin Island proudly remains, surrounded by the azure waters of the sea, which constantly seek attention to tell the stories of Dongyin.

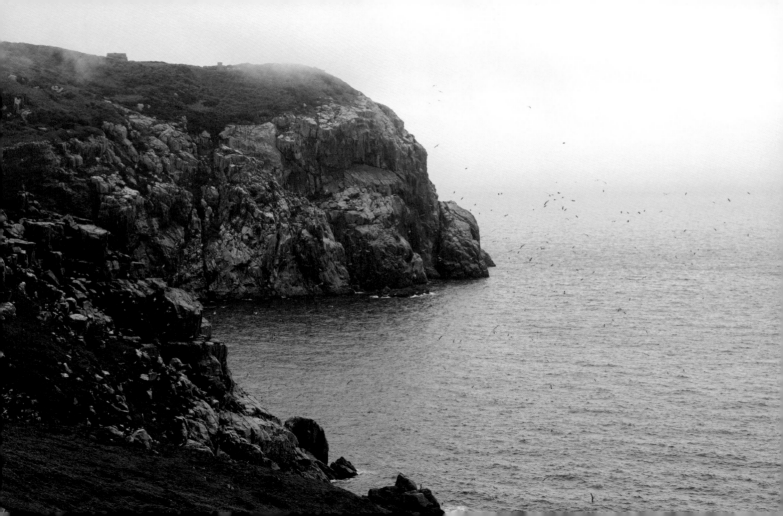

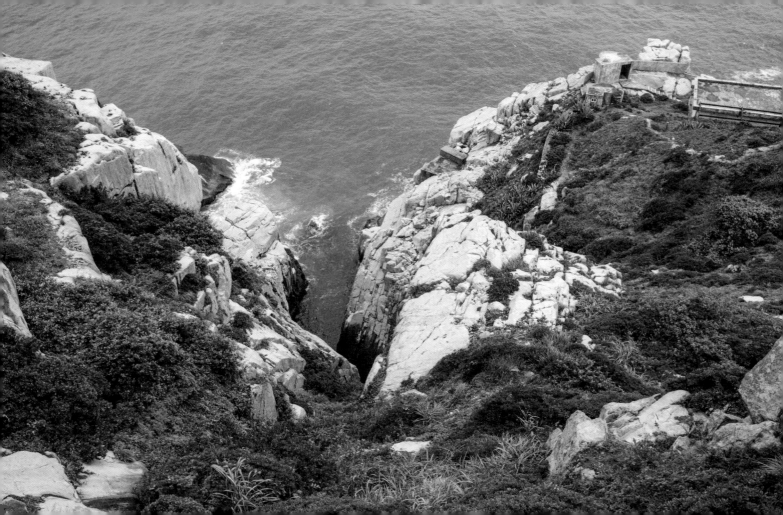

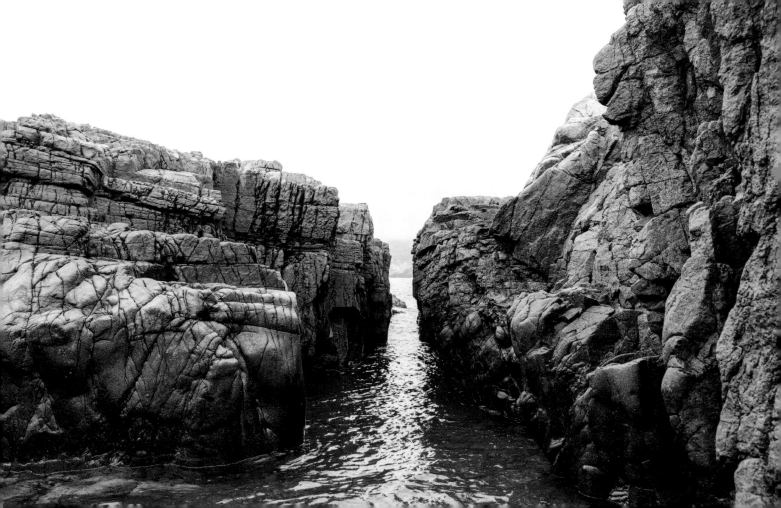

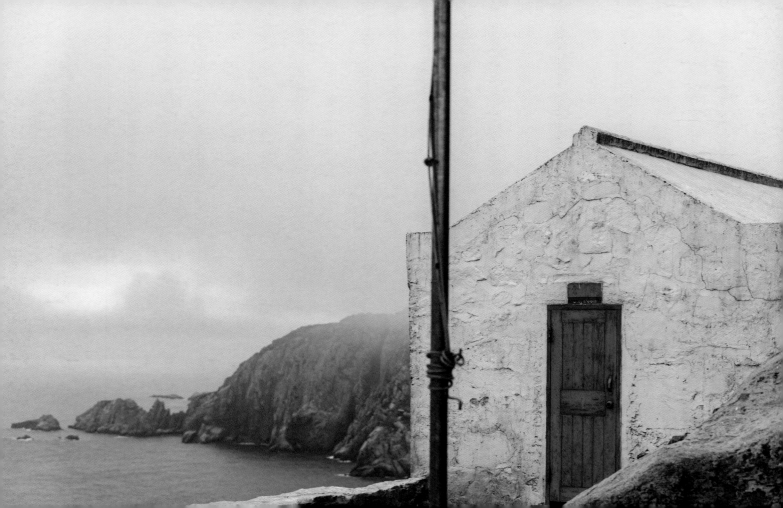

馬祖國際藝術島總策劃的 5 個思考
Five Rationales in Planning the Matsu Biennial

「風土」交會，策劃的起點

遠至而來的風與在地的土交會，擾動島嶼同時留下更深厚的沃壤，這是馬祖自 1990 年代至今重要文化運動的推動關鍵。諸如聚落保存、社區營造與文化資產保存、再造歷史現場等，都是島外各方專業與島上不同世代居民協作下的成果。這也是我們策劃馬祖國際藝術島的核心，在各策展計畫中引入風土交會機制，如「迴島嶼吧」從馬祖島與島的能量流動延展到和台灣島之間的風土對話，如「地下工事」的策展場域：南竿 77 據點，從在地藝術家駐點的畫室到國內外創作者匯集之地，更如「馬祖國際藝術島」奠基於馬祖世代接續傳承的文化底蘊，邀請台灣各界專業登島，共同開展與世界的風土交會。

「時間」積累，醞釀永續的島嶼

從藝術季到藝術島，我們思考藝術季的開展如何催化島嶼轉型，讓當代節慶帶來好的質變能根植島嶼，走入島民生活日常。而深耕的關鍵便是時間，藝術島從一開始的籌備就歷經數年與專業界、在地單位的討論，逐步設定馬祖國際藝術島以每 2 年一次的週期，在目標 5 屆、長達 10 年的時間向度裡展開當代馬祖轉型課題的探討，或許藝術島無法回應所有挑戰，但可以開放嘗試和更多討論、作為永續島嶼的公共倡議。

「計畫」耕耘，延續觀照

有了長時間積累的設定，創作於是能突破過往一次性活動、只能用作品分配議題而無法跨屆延續的困境。馬祖國際藝術島以關注不同切角的計畫為 10 年耕耘的軸線，當代藝術計畫觀照創作與社會的對話，地方共創計畫試圖叩問在島與島之間的地方創生可能，地景建築計畫梳理地貌歷程、為下個 30 年的空間治理摸索實現路徑，教育和志工計畫則創造學習和培力的機制，讓島嶼文化能自信傳承。在官方計畫之外，也試著在民間擾動、促發具潛力的種子計畫，如協力地方民宿邀請專業者上島以沙龍座談換宿，刺激馬祖的公民交流、公共參與能量，如以藝術探照升學導向之外的教育議題，更多元詮釋運動或專業技能的價值和意義。

The Meeting of the Wind and the Soil:
The Beginning of the Planning

The whirling wind from afar leaves fertile soil after visiting the islands. This is how Matsu's nature is formed and how cultural initiatives have developed in Matsu since the 1990s. Settlement preservation, community construction, cultural heritage preservation, and the regeneration of historic sites—all these activities in Matsu resulted from collaboration between generations of islanders and professionals from outside the islands. Thus, the encounter of wind and soil inspired the conception of the Matsu Biennial's curatorial projects. "*Returning to the Island*" is a conversation between Matsu and the island of Taiwan from the perspective of the energy flowing across the archipelago, and. "*Underground Matters*", the project located at stronghold no. 77, turns the former military site into studios for both local and foreign artists. Rooted in and drawn from the culture of Matsu, this Biennial invites professionals of various backgrounds to the islands to explore the encounter with the world.

Fermenting with Time:
Brewing the Sustainable Islands

Starting with the notion of an arts festival, we have contemplated how such an event could facilitate the transformation of an island and bring about essential changes in the daily lives of islanders. We deemed that such a cultural evolution required time, so this Biennial has been in preparation—or brewing—for years through ongoing discussions between experts and the residents of Matsu. This resulted in the decision to conduct an experiment in Matsu's contemporary transformation by holding five Biennials over the course of ten years. Although an arts event, such as this Biennial, is not the answer to every challenge, it nevertheless promotes public discussion and creates the potential for initiatives that could make Matsu an island of sustainability.

Extended Projects, Extended Observations

Thanks to its long-range framework, the Matsu Biennial does not face the predicament associated with one-off activities that cannot sustain a focus on their concerns, thus enabling the cultivation of various initiatives for at least ten years.

In such a timeframe, these contemporary art projects can promote conversation between art creations and society. The local co-creations can explore the potential for interisland collaboration, the landscape architecture projects can document the transitions of landforms and scout the paths to governing the space for the next thirty years, and the educational and volunteer projects can build mechanisms for learning and for strengthening the charming culture of the islands. In addition to these official projects, this Biennial facilitates grassroots initiatives, for example, by evoking the power of public participation in Matsu by collaborating with local guesthouses and inviting experts to give talks in exchange for accommodation or by probing the issues of test-oriented education through the practice of art, enabling a broader understanding of professional skills or sports.

「空間」向度，從背景到自明

其中，地景建築不只作為計畫類型之一，亦為一種作品類型——在本屆藝術島有建築景觀作品的選件。地景建築之於藝術島的重要性，來自我們對島嶼空間的觀察：重新開放的戰地文化景觀或新建的公共設施是藝術島最重要的空間載體，也是對在地人而言最具公共性的作品，「一幅完成中的風景」梳理後戰地政務時期變遷 30 年的島嶼空間紋理，也有助於辯證馬祖的建築景觀自明性，從而在可預見的未來裡，面對大型基礎建設如跨海大橋的建置，能有原則可依循。將空間納入藝術島的關鍵向度之一，讓日常的硬體建設開始思考與藝術島的軟體創作或營運整合，也讓更多公共對話加入島嶼空間治理的討論。

「文化」永續，島嶼轉身的支點

馬祖國際藝術島希望引動的不只是面向公眾的文化運動，也包括公務體系的組織變革，讓島嶼治理的最初和最終目標是文化永續。於是我們將傳統的文化政策語彙轉化為跨局處文化治理的可執行方向，例如結合「景觀總顧問」與藝術島籌備，讓公共工程有日常把關、亦有 2 年一次的目標檢核，又如以「設計導入」在交通旅遊、產業發展單位的既有計畫中，重新討論人本與地方紋理。以 10 年的藝術島帶動行政組織的文化變革，讓藝術島成為馬祖新世代人才的培育平台。

這 5 個面向的思考，並不是單一的向度，而是綿密動態的網絡關係。因為「空間」與「時間」承載 20 多年來的「風土」交會；因為有了「時間」的等待，才有「計畫」的深度與「文化」的醞釀；也因為有了「文化」的思維，才能創造馬祖獨特的「空間」文化氛圍，承載最具島嶼性格的「計畫」。這 5 個思考如同島上 5 同人際網絡的牽動，以及跨計畫與專業團隊間的整合，綿密地把所有的人與事組織起來，成為馬祖國際藝術島的思考與核心方法。

The Place:
From Background to Identity

Landscape architecture is a type of project as well as a genre of art with its own highlighted selection in this Biennial. The importance of landscape architecture to the Biennial derives from observation of the islands' spaces: the now-accessible cultural landscape of the war zone as well as the newly built public facilities that are the Biennial's extensions in space as well as symbols of the public to the islanders. *Islands in Evolution* addresses the spatial context of the islands over the past thirty years of post-war zone administration, a context that not only inspires contemplation of the identity of Matsu's architecture but also serves as a reference for the construction of major infrastructure projects (such as the interisland bridge) in the foreseeable future. Incorporating space as a key curatorial element of this Biennial allows art to intervene in the construction and operation of Matsu's infrastructures and introduces the voice of the people to the governance of space on the islands.

Cultural Sustainability:
Pivot for the Islands' Transformation

The Matsu Biennial ultimately wants to inspire not merely a cultural movement of the people but a revolution in the bureaucratic system that leads to promoting cultural sustainability as the primary and final goal of governance on the islands. That is why we translated abstract cultural policies into the concrete operations of cultural governance, such as by inviting the government's General Landscape Consultant into the organization of this Biennial, allowing art practices to be a part of public constructions while conducting a critical review every two years, and adopting design thinking in the planning of Matsu's tourism, traffic, and industrial development to reconsider their cultural and spatial implications. Driving a cultural revolution in the bureaucratic administrative system through a ten-year art project, the Matsu Biennial also looks forward to being a platform that incubates young talent on the islands.

These five rationales do not run in parallel but, instead, form a dynamic, interrelated network. Time and space influenced the encounter of the wind and the soil over more than twenty years. Time brewed the cultural flavors and the diversity of this curation, and culture created the unique spatial and aesthetic ambience for the birth of this curation's projects. The five rationales draw upon the social network of the islands and foster close collaboration between the projects and the professional teams; they constitute the logic and approach of the Matsu Biennial.

總策劃 ——— 吳漢中

自 1990 年代就讀台大城鄉所時期與馬祖的相遇，擾動了島與島間的風與土，就已經播下了這一顆種子，促成了 20 年後馬祖國際藝術島風土交會的緣分。

　　畢業於台大城鄉所與杜克大學 MBA，深信設計與文化治理能夠啟動組織文化變革，創造社會影響力，長期投入國際級大型博覽會與藝術季總策劃工作，曾擔任 2019 浪漫台三線藝術季設計總監、2018 台中世界花卉博覽會設計長、2016 台北世界設計之都辦公室執行長。

　　延續 20 多年前的緣分，5 年前的機緣與近 2 年的田野，提出整體 10 年 5 屆規劃，以設計專業與行政分工的籌備機制統籌整體策展計畫，並陪伴行政團隊共同推動組織文化變革，與公部門、各界專業、在地世代分工協力，共同梳理當代馬祖的價值與挑戰，以邀請更多人和島嶼一起思考、學習，用 10 年堆疊以文化自信為底蘊，而能在世界定位自己的島嶼生活。

Master Planner ——— Wu Han-Chung

Wu Han-Chung visited the islands along with the wind in the 1990s, and his encounter with Matsu planted the seed for the Matsu Biennial over twenty years later.

　　With a degree from National Taiwan University's Graduate Institute of Building and Planning and an MBA from Duke University, Wu believes that design and cultural governance can trigger a revolution in the culture of bureaucratic systems and generate social impacts. Devoted to the curation of international expos and art events, he has served as the Design Director of the Romantic Route 3 Arts Festival in 2019, the Chief Design Officer of the 2018 Taichung World Flora Exposition, and the Executive Director of the World Design Capital Taipei in 2016.

　　Wu, who learned about this project five years ago, proposed the plan for five biennials spanning ten years after conducting two years of field study that built on the relationship with Matsu that he had cultivated over twenty years ago. In this proposal, the preparation work for the Biennial is divided between design and administration. Wu coordinates the two areas of preparation as well as the curatorial projects while facilitating a revolution in the organizational culture of bureaucratic systems with colleagues from the administrative team. Through this Biennial, Wu hopes to investigate Matsu's contemporary values and challenges, working with both the public and private sectors as well as islanders to build cultural confidence within ten years, enabling the world to enjoy a renewed vision of the islands' culture.

計畫區域分布圖
Project Locations

南竿

藝術｜地下工事 ●
　　　迴島嶼吧 ●
　　　傾聽島嶼的聲音 ●
　　　島嶼生息 ●
建築｜一幅完成中的風景 ■
　　　當代建築選件 ■
　　　戰地轉身・轉譯再生 ▣

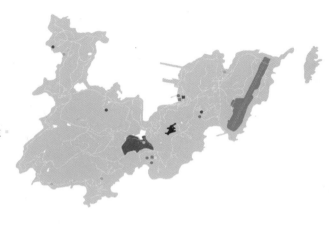

北竿

藝術｜地下工事 ●

東西莒

藝術｜迴島嶼吧 ●

東引

教育｜風塔 ▲

詳情請見馬祖藝術島官方網站

本圖為示意圖，非實際比例圖 This map is not to scale.

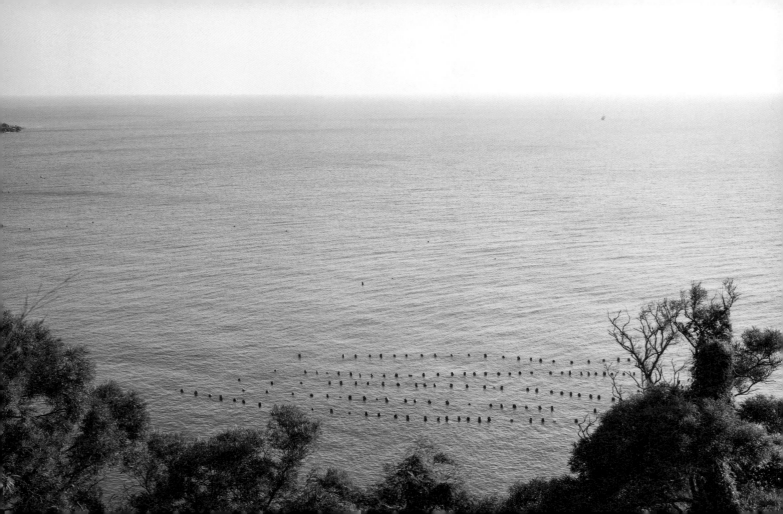

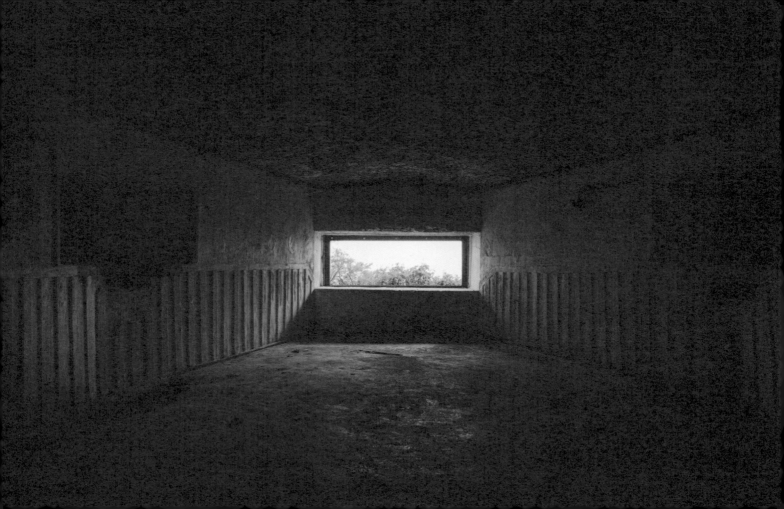

地下工事
藝術計畫
Underground Matters

離島是一種相對的空間概念，是因不熟悉的遠望所造成的視差。「地下工事」原泛指地面以下修建具防護性能的地道、防空洞作為主題，除了在意象上點出馬祖具高度密集的軍事坑道部署的戰地地景，也進而冥想著蟄伏於地下的身體勞動以及逝去的文化意象。本展透過拾尋地方文化符碼與軼事，跨越分歧找到連結彼此的敘事，帶出「地下工事」之於當代的意涵與想像。

"Outlying island" implies a subjective conception of space, a parallax that emerges by looking into the unfamiliar distance. Underground Matters, inspired by protective passageways and air-raid shelters constructed below the ground, meditates on the physical labor and the vanished cultural impression of Matsu by capturing the warzone landscape of the extensive military tunnels. By collecting local cultural symbols and stories, this exhibition aims to reveal narratives capable of bridging the discrepancies, evoking the contemporary associations and imaginings of "underground matters."

● **作品數量　7 件**
● **展出地點　南竿 77 據點、南竿山隴排練場、南竿軍人紀念公園、北竿后澳民宅**

策展人 ——— 林怡華

山冶計畫創辦人，林怡華擅長跳脫常規展域進行跨域實驗性操演，同時關注藝術的在地實踐以驅動藝術能動性。近期策展包含 2017 年映像節「破壞控制」、2018「南方以南」南迴藝術計畫、2019 北埔藝術小鎮「未來的昔日」、2019「池田亮司個展」台北市立美術館、第七屆台灣國際錄像藝術展「ANIMA」、2020 台北雙年展「你我不住在同一個星球上」公眾計畫。

Curator ——— Eva Lin

The founder of mt.project, Eva Lin is known for curating at unconventional venues, where she engages in the experiments that constitute her interdisciplinary practice. Lin's dynamic interests inspire her alternative thinking and responses to cultural production in diverse forms. Her recent curatorial projects include Parallax: Damage Control in 2017, The Hidden South in 2018, The Upcoming Past and Ryoji Ikeda Solo Exhibition in 2019, and, in 2020, the Seventh Taiwan International Video Art Exhibition – ANIMA and the public program for theTaipei Biennial.

地下的故事
一永夜淘光
Underground Narration —
Digging Light in the Eternal Night

曹楷智
Tsao Kai-Zhi

藝術家提供

作為馬祖主要的藝術家與文化行動者，曹楷智致力於在地藝文發展與深耕美術教學。進駐南竿 77 據點後，日以繼夜地親身勞動，將廢棄坑道轉譯為藝術家工作室與交流空間，更不忘將自身創作的能量投入於在地發展的理想性。坑道地面以工作狀態呈現其藝術創作的軌跡，坑道地下除保留原有的戰地遺跡，亦呈現出藝術家透過身體銘刻不可見的勞動，象徵著那些被隱匿在地下的軼聞故事。

—

📍 **南竿 77 據點**　26.16895, 119.91649

The surface of the tunnel presents the trajectory of Tsao's artistic creation in a working state while the underground of the tunnel preserves the original remnants of war, showing the artist's unseen labor inscribed through his body and symbolizing the anecdotal stories that have been hidden.

靜候之景：馬祖列嶼
The Elapse：Matsu

丁建中
Ding Chien-Chung

藝術家提供

一年中有四分之一的日子，馬祖列嶼浸潤在霧裡。這段日子，馬祖居民眼中的四周與遠方，都透著一層潮濕的濾鏡。本裝置以乳白感濕油墨印刷之平面攝影，透過裝置反覆以水霧浸濕。於馬祖列嶼幾處在不同時間望向海面所採集的影像，隨濕氣浮現又消散。或許岩岸節理、或許廢棄的戰備道，或許望向抽砂船包圍的海面、或許望向島與島間……。作品旁側的坑道射擊窗外，腥鹹海風浮聚再消散，伴隨裝置影像一同迴盪著往復循環的潮濕記憶。

—

📍 **南竿 77 據點**　26.16895, 119.91649

In this installation, creamy, moisture-sensitive photographic prints are repeatedly soaked in the mist, and those images of sea views - captured from different angles at different times and in various locations on the islands - merge and disappear along with the mist, whether depicting the patterns of rocks, abandoned road bases, the sea surrounded by sand pump dredgers, or simply a view between the islands.

水流之神
God Flowing in the Water

陳飛豪
Chen Fei-Hao

藝術家提供

馬祖作為由多個島嶼組成的生活共同體，與海洋或者說與「水」的關係極為密切。其中關於「水流屍成神」的應公信仰，即早期漁民發現遇海難的浮屍，會撈捕上岸並且妥善處理進行安葬，隨著神蹟的出現，會從水流屍轉化成為地方鄉土神，在馬祖最具代表為西莒威武陳元帥，以及南竿的梅石高總管、福澳林大姐、北竿的楊公八使等等，連香火最盛的媽祖信仰也在此沾染了近似的色彩。本作則透過檔案影片、自撰文字與紀錄性影像等結合影像裝置形式，探索該風俗背後的文化想像與在地意識。

—

📍 **南竿 77 據點**　26.16895, 119.91649

This work explores the cultural imagination and local consciousness behind the custom of transforming flowing corpses as gods in Matsu through archival film, self-authored text, and documentary videos, combined with video installations.

照理來說 應該可行
In Theory, It Should Be OK

利安・摩根
Liam MORGAN

藝術家提供

本作品探索了藝術家在過往創作中所關注的孤立、人造自然景象議題，及藝術家對台灣過去和現在的地緣政治處境的觀察，坑道是一處島民在此經歷長時間躲避未定義的危險，被視為一組未來，或替代現實的場景。本作品在地下坑道內設置植物，用人造光線與水源澆灌以維持其生命系統，隱喻過去戰事期間坑道內士兵的生存樣態，深探人類隔離之概念及身體對應內外空間的關係，透過移動行走與燈光裝置所產生的無意識敘事，開啟了身體之於地下空間的多元感受。

—

📍 **南竿 77 據點**　26.16895, 119.91649

This work delves into the concept of human isolation and the relationship between the body and internal and external space. Through the unconscious narrative generated by walking and the lighting installation, it opens up the body's diverse perceptions in the underground space.

採光
Daylighting

邱承宏
Chiu Chen-Hung

藝術家提供

「採光」原指因為都市化及工業化之後，重新挖開被埋藏在地底深處的遺留建物，讓地底下的溝渠或水道重見天日。藝術家將此概念轉化對於空間的處理，進行一場歷史與美學造型之間，將時間軌跡拉出的考古挖掘工程。以地下軍事設施的室內窗景為依據，重新將窗外的植物風景為構圖雕鑿在空間的牆面上。藉由雕鑿毀壞原本的物理空間，同時重建出過去某個日常片刻的輪廓，藉此疊合跨時的印記，不同時空脈絡的物質、光影與角落相互成為彼此共生的形體，創造出一處另類的歷史風景。

—

📍 **北竿后澳民宅**　北竿鄉后澳村 4 號 ,12 號

By destroying the original physical space and reconstructing the outline of the past, this work is a carving overlapping the imprints of time and space, turning materials, lighting, and corners of different times and spaces into symbiotic forms, creating an alternative historical landscape.

漁火
Chorous

劉致宏
Liu Zhi-Hong

藝術家提供

馬祖春分到穀雨、清明之際是黃魚洄游東引海域產卵的時機。作品《漁火 Chorous》圍繞在早期漁民「聽音辨位」尋找魚群的特殊漁業文化，此次創作邀請盧森堡籍海洋科學研究員 Sven Gastauer 加入協作，以紐澳與大西洋等海洋聲納探測研究 (acoustic susceptance) 對照舟山群島、馬祖東引橫山等地聽音辨位文化，同時結合燈塔頻率與明滅間隔的模擬，再現東引與東莒兩座燈塔的白聯閃光，跨越物理距離相互發送訊號、述說對話與馬祖故事。

—

📍 **南竿山隴排練場**　南竿鄉介壽村 330-5 號

Chorous evokes how early fishers found fish by "listening" to their locations and simulates the flashing frequency of the lighthouses at Dongyin and Dongju, reinterpreting their transmission of signals across a physical distance as though they are communicating and telling the stories of Matsu.

珠螺村藝術裝置
Zhuluo Art Installation

廖建忠
Liao Chien-Chun

馬祖不僅為東亞區生物分布的樞紐地帶，更是古往今來商船貿易進出福州必停留之處，珠螺村是島上少有的農業區域，因戰務改寫了村落的際遇，原有的常民生活也隨之潛藏於花崗岩鑿的坑道之下。列島上稀有的原生種植物紅花石蒜，別名為「彼岸花」，也是馬祖的縣花。藝術家仿生榴彈砲砲管，將之轉化為枝幹，頂上開散花葉相見的紅花，象徵卸下前線使命後持續綻放嶄新的未來意象，在往昔與未來、山風與海景聚合之處，綿延著過去的思念轉身眺望不再失落的故鄉。

Liao conceives the howirzer gun as a branch that blossoms with red flowers that do not wither at a place where the past and future, mountain breeze and seascape converge, symbolizing the ambiguous history of the island and the multifaceted Matsu imagery that continues to blossom after the war.

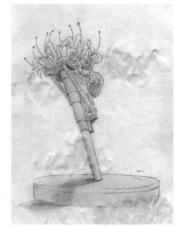

藝術家提供

🕐 戶外開放空間
📍 南竿軍人紀念公園
26.15657, 119.92777

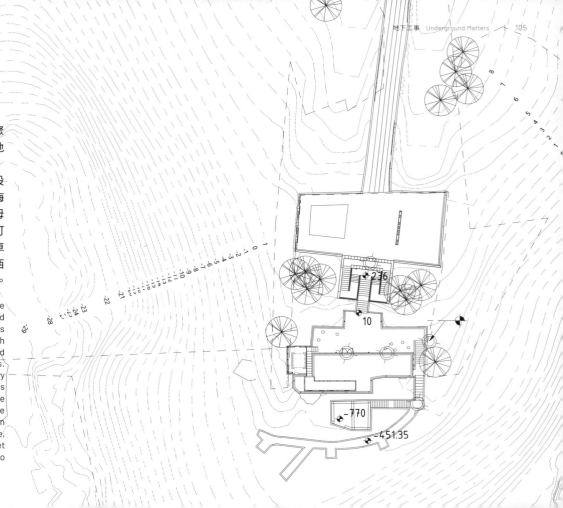

地下工事展場：

南竿 77 據點
Stronghold no. 77, Nangan
26.16895, 119.91649

位於南竿西北角鄰近四維聚
落，77 據點建有地上一層與地
下一層基地，內現有舊營舍、
地下坑道及其他相關附屬設
施。由舊有營舍可眺望整片海
景，步行 10 分鐘可達四維天母
宮與周邊小型聚落，15 分鐘可
達藍眼淚生態館。基地往南車
程約 10 分鐘可達馬祖港，往西
車程約 20 分鐘可達南竿機場。

Located in the vicinity of Siwei Village
in the northwest of Nangan, Stronghold
no. 77 has one floor above ground as
well as one below. It is equipped with
a military dormitory, underground
tunnels, and various other facilities.
There is a sea view from the dormitory
windows, and a ten-minute walk takes
you to the Tianmu Temple and the
neighborhood of Siwei. The Matsu Blue
Tears Ecological Museum is fifteen
minutes away by foot. From the base,
driving south for ten minutes will get
you to the harbor and west for twenty to
Nangan Airport.

© 不廢跨村實驗室，路上藍眼淚計畫——《島塑椅》

迴島嶼吧

藝術計畫

Returning to the Island

讓我們一起迴島嶼吧。回來，迴來，在藝術島的行動中促成島嶼間的交流。從四鄉五島內的合作，進而讓離島經驗與本島對話，是以島為家走向國際對話的動態過程。

在「迴島嶼吧」的策展精神下，藝術試圖回應島嶼內「信仰文化」、「自然環境」的消失與重生，並從味蕾的儀式感中建立關於「海洋」、「植物」、「傳統」的知識學；進而共創則以島嶼為學校，在「島嶼研習所」行動中建立經驗上的離島關係人口，持續積累藝術島動能。

依此，島嶼共創在擺暝文化及環境議題下，以「信仰」、「傳說」、「植物」、「環境」為題發展共創作品，透過味蕾實驗的交流促成離島與本島的經驗對話，而藝術島的志工模式建立，持續性的累積未來馬祖藝術島十年的動能。

Under the curatorial spirit of *Returning to the Island*, the art tries to respond to the disappearance and rebirth of faith culture and natural environment on the island, and to establish the knowledge of sea, plant, and tradition via the rituals of the palate.

Accordingly, the island co-creation will develop co-creative works using the themes of faith, legends, plants, and environment under pě-màng nocturnal culture and environmental issues, and facilitate dialogues between the experience of the main island and the outlying islands through the exchange of palate experiments.

● **作品數量　6 件**

📍 **展出地點　東莒中正堂、東莒 64 據點、東莒神祕小海灣、東莒大浦聚落、
　　　　　　　南竿日光春和・西尾半島・依嬤的店**

策展人———— 黃鼎堯

在 16 年的藝術與社區陪伴經驗下，持續探討地方、青年、藝術、產業等課題的實踐。2012 年並以「村是美術館、 美術館是村」作為號召，成立台灣第一座農村美術館，2020-2021 年為礦山藝術季策展人。

Curator ———— Huang Ding-Yao

With 16 years of experience in art and community engagement, Huang Ding-Yao continues to explore the practice of art in relation to young people, industry, and the local environment. In 2012, he established Taiwan's first rural art museum with a call for "the village being an art museum and the art museum being the village." He was also the curator of the 2020-2021 Mine Art Festival.

策展人———— 陳泳翰

2018 年起接觸馬祖東莒島大浦聚落活化計畫，與團隊成員共同蹲點馬祖，結合社區營造、藝術駐村、地方創生，辦理「大浦 plus」計畫，嘗試以小島為基地，摸索出回應、克服當代偏鄉困境的不同路徑。

Curator ———— Chen Yung-Han

Since 2018, Chen Yung-Han has been associated with the Dapu Community Revitalization Project on Donju Island, Matsu, and has worked with team members in Matsu to implement the Dapu Plus project, which combines community building, art residency, and placemaking to use the island as a base for exploring diverse ways to address and overcome the contemporary plight of remote villages.

跨越海洋——
島嶼前線紀事
Ocean-Crossing : Chronicles of Island's Frontiers

差事劇場
Assignment Theatre

軍管時期的燈火管制，一度讓跑火賽、打鼓板等傳統民俗活動無以為繼，卻也讓居民留下其他地區人民罕有的生活經驗。本作品將以軍管時期前後的島民生活作為故事挖掘，以地理環境中的海、火及藝術裝置作為元素，呈現島上軍民共生共存的生活變遷，融入信仰儀式、身體於環境意象的故事。藝術創作基地跨越東莒及西莒，並以踩街結合藝術展演，將常民生活記憶及儀式再現，藉由跳島展演串連島嶼交流，將跑火賽、打鼓板融入藝術展演創造地方活力。

—

劇場演出

🕐 **2022/03/22**　🕐 **2022/03/24**　　**作品展覽**

📍 **東莒坪西營區**　📍 **西莒威武陳元帥廟**　📍 **東莒中正堂**

This work explores life under military control and uses lighting as an element to present the story of changes to the lives and rituals of common people. Street strolling is combined with art performance to recreate the memories and rituals of common folk.

鐵鏽物件－東莒植物、
礦物與鐵鏽染色計畫
Dongju Dyeing Project - Rust and Natural Dyeing

鐵鏽物件｜陳穎亭
Rusted Objects | Chen Ying-Ting

馬祖列島留有許多軍事痕跡，空間上與心理上皆然。藉著鐵鏽染與植物染的記錄，將人們曾經的軍事年代記憶以鐵鏽染的方式顯影再現。將軟性、帶有鐵鏽染的布料，裝飾於剛硬、帶有肅殺之氣的廢棄軍事據點，轉化其對抗性質。此外，戰地經驗也改變了島上的植物相，藉由植物染的方式留下紀錄，於軍事據點荒廢房舍內部陳設，讓植物科學成為空間美學的一部分。

—

📍 **東莒 64 據點**　25.9506357,119.9778754

In this work, military-related objects are being collected and dyed on fabric using rust dye, decorating the soft, rust-dyed fabric in the abandoned military stronghold to transform its hard, stern, confrontational nature.

路上藍眼淚計畫
——《島塑椅》
Blue Tears Land Project:
Have an ISLAND SEAT

不廢跨村實驗室
楊芳宜、林俊作、彭宇弘(起夫)、
吳宜靜、林資芬、林季樺

以馬祖特有的「藍眼淚」反應沿岸生態環境維護的重要為概念發想，發展「路上藍眼淚計畫 ——《島塑椅》」作品，進駐後以淨灘撿拾海廢垃圾並轉化為再生材料，製作可實際使用的展品元件，使其分布在島上，邀請人們入座欣賞世界級美景的同時，也加入維護島嶼生態的實際行動，再塑生態永續之島。

The project collected sea waste from beach cleanups and transformed it into recycled materials to create practical exhibition components that were distributed on the island. The audience is invited to take practical action to preserve the island's ecology.

NO!W Across Lab
Yang Fang-Yi , Lin Chun-Tso, Peng Yu-Hong, Wu Yi-Jing, Lin Tzu-Fen, Lin Chi-Hua

—

📍 東莒神祕小海灣

犬島海馬 – 土擺暝
Dog Island Ocean Horse -
Dirt of Sacrifice

土偶｜吳其錚、陳瑋軒、
　　　韓昀庭、徐育霓
扌日土｜黃妙貞

以小島生活樣態、地景與傳說為主題延伸出兩組擺暝慶典供桌。從料理、食器、供桌的桌面及桌腳，甚至是裝飾性物件，設計出與傳統風貌截然不同的全方位盛宴，作為答謝島上諸神全年的庇佑，帶有各個聚落意涵的各種造型陶馬也作為聖獸，排排站在廟口祝賀這一次的慶典。

The island's lifestyle, landscape, and legends inspired the creation of two sets of ceremonial tables for the pě-màng celebration. From cuisine and utensils to table tops, table legs, and decorative objects, the team has designed a holistic feast that diverges from tradition.

Clay doll | Wu Chi-Zeng ,Chen Hoo-Sin , Han R-Ting,Hsu Yu-Ni
Soul-z-Soil | Huang Miao-Chen

—

📍 東莒大浦聚落

島嶼味蕾實驗室
Island's Taste Lab

日光春和、西尾半島、
依嬤的店
DAYSPRING, XIWEI PENINSULA
ANTENNA SHOP, YIMA's kitchen

在藝術島的行動中，尋找關於海洋、植物、傳統的料理，我們尋找著長年深耕馬祖的青年夥伴，藉由料理及餐桌的儀式，在味蕾中分享島嶼的故事。

—

🕐 **2022/2/15-2022/3/15　每日 20 份 (採預約制)**
📍**依嬤的店**　南竿鄉復興村 72-1 號

　日光春和　南竿鄉仁愛村 1-1 號

—

🕐 **2022/2/18-2022/04/10**
　每週五、六、日午餐時段提供，每日 8 份（採預約制）
📍**西尾半島**　南竿鄉四維村 21 號

For this biennial, this initiative seeks cuisine that reflects the sea, plants, and traditions. It calls for young partners who have been deeply involved in Matsu for years and share their stories of the island through plates, cuisine, and rituals at the dining table.

島人廚房
Islander Kitchen

墊墊胃 X 吳謝私廚
Diandianway, WuHsieh Lab

在藝術島的行動中，以島嶼作為廚房，邀請台灣團隊駐點創作，從田野、採集、傳統進而轉譯島嶼特色食材，在味蕾的分享中創造島與島之間的經驗交流。

—

🕐 **2022/2/15-2022/3/15　墊墊胃，每日 20 份（採預約制）**
　2022/3/15-2022/4/10　吳謝私廚，每日 20 份（採預約制）
📍**東莒大浦聚落**

In this project, the island is used as a pantry, and the team from Taiwan is invited to reside and translate the islands' special ingredients through field research, collection, and tradition to create an exchange of experience between the islands in the sharing of flavors.

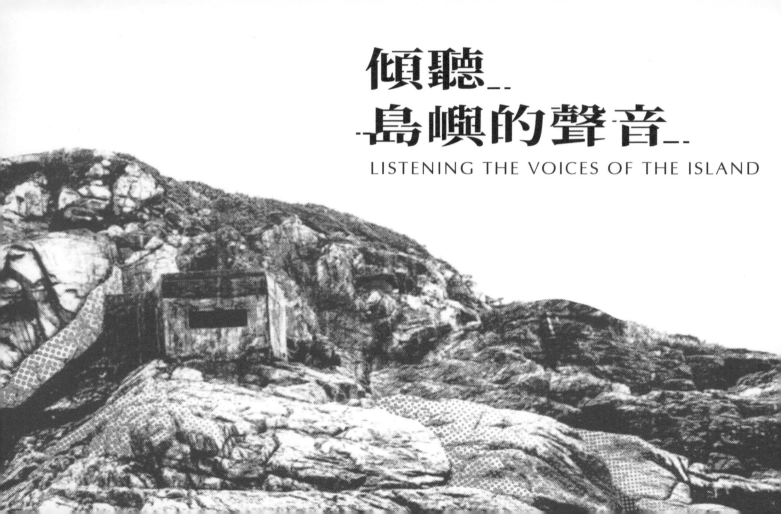

傾聽
島嶼的聲音
LISTENING THE VOICES OF THE ISLAND

傾聽島嶼的聲音

藝術計畫

Listening the Voices of the Island

「傾聽島嶼的聲音」是一個重新思考馬祖這塊土地的藝術採集與創造計畫。整體計畫以場域系譜的研究與調查為基礎，以地景作為檔案（Landscape as Archive）的觀點，從地景資源的再發現，從我們所見、所聞、所觸的環境感知參照馬祖獨特的歷史脈絡與社會組成，以理解與再現地景的動態過程，從而開啟新的島嶼認識論。

Listening the Voices of the Island is an art collection and creative project, based on field research and the analysis of site genealogy, that invites audiences to reconsider Matsu. The project aims to inspire a new island epistemology by adopting the perspective of "Landscape as Archive", by rediscovering landscape resources, engaging in the dynamic process of understanding and reproducing the landscape, and by perceiving the environment from what we have seen, heard, and touched with reference to the unique historical context and social composition of Matsu.

● **作品數量　1 組空間展覽（9 件作品）、9 件現地創作作品**

● **展出地點　南竿馬祖民俗文物館、南竿 53 據點**

策展人 ——— 陳宣誠

1978 年出生於台南，現居住及工作於台南、台中、桃園。國立臺南藝術大學藝術博士，現為中原大學建築系專任副教授、共感地景創作｜ArchiBlur Lab 主持建築師。

長期探索在身體與地景間發展另一種重新定義建築的尺度，企圖用最真實的身體感，反覆去體會事物最根本的價值，讓建築成為一種關於人與非人的環境。

Curator ——— Chen Xuan-Cheng

Born in Tainan, Taiwan in 1978 and currently residing and working in Tainan, Taichung, and Taoyuan, Chen Xuan-Cheng holds a PhD in arts from Tainan National University of the Arts. He is currently a full-time associate professor in the Department of Architecture, Chung Yuan Christian University, and chief architect of ArchiBlur Lab.

Chen has long explored the development of a scale that redefines architecture between the body and the landscape, employing the most realistic sense of the body to continually investigate the fundamental value of things so that architecture becomes an environment of both people and non-people.

協同策展人 ——— 廖億美

好多樣文化工作室創辦人，國立臺北藝術大學藝術管理碩士。

2007 年開始參與及推動馬祖後戰地時代的多項文化議題，並關注如何在原有脈絡下介入新的視角、架構新的工作方法、促成新的對話與論述。多年來在邊緣的位址，差異的位置，致力於發掘、深化與轉譯馬祖的文化內涵，以及文化多樣性的實現。

Co-Curator ——— Liao Yi-Mei

Liao Yi-Mei is dedicated to exploring, deepening, and translating the cultural connotations of Matsu and the realization of cultural diversity. She is concerned with how to intervene with new perspectives, structure new methods of work, and foster new dialogues within the original context.

傾聽島嶼的聲音
Listening the Voices of the Island

「傾聽島嶼的聲音」是持續性的藝術介入行動，企圖建立一種滾動循環的地方研究，藝術是啟動這一循環的動能。

　　展覽於馬祖民俗文物館 1F 特展區與南竿 53 據點，展出建築師、景觀建築師、視覺藝術家、聲音藝術家、歷史學家、植物學家、攝影家……等，所進行的島嶼採集到創造，更是累積一種可持續工作的方法論，透過藝術創作計畫，挖掘出不同層次的觀點，重新連結島嶼、海洋、歷史、人與環境，進一步提出關於未來的想像。

Listening the Voices of the Island is a continuous artistic intervention, attempted to establish a rolling cycle of local research, and art is the energy that initiates this cycle. The exhibition is held at the Matsu Folklore Culture Museum 1F and Nangan Stronghold no. 53, exhibiting the collection and creation of islands by architects, landscape architects, visual artists, sound artists, historians, botanists, photographers... etc. It is also accumulating a methodology for sustainable work, dig out different levels of viewpoints through artistic projects, reconnecting islands, oceans, history, people and the environment, and further propose imaginations about the future.

—
📍 南竿馬祖民俗文物館

傾聽島嶼的聲音展場（一）：

馬祖民俗文物館
Matsu Folklore Culture Museum

馬祖民俗文物館距離福澳碼頭車程距離 10 分鐘。主體建築採閩東風格，以高低錯落的聚落型態，由點、線、面、體的結合，突顯馬祖獨特的閩東建築文化。一樓設有多媒體展示區、植物展示區、生態展示區、紀念品展示區與印象館，展現馬祖的地理空間、海洋、地質、植物、鳥類等意象。

The main building of the Matsu Folklore Culture Museum is built in the Mindong style, with a staggered pattern of high and low clusters, accentuating Matsu's Mindong architectural culture. On the first floor, there are display areas for multimedia, botanics, ecology, a souvenir, and an impressions museum, which exhibit Matsu's geography, ocean, geology, plants, birds, and other imagery.

展出作品
Exhibited Works

01　流光群島
Liquidity Islands

02　鄉音為響 - 點名
Land and Lingo - Make The Call

03　枕待
Wait Till

04　拜訪瓊麻 1
Being around Sisal I

05　回填
Backfill

06　對象、景框、射口、掩體 - 射口
Objects, Frame, Loophole, Bunker - Loophole

07　粗曠、侵蝕與抵抗 - 質感採集
Roughness, Erosion, and Resistance - Texture Collection

08　一座遠離海洋的島
An Island Far from the Sea

09　島嶼的凝望
A Steady Gaze Falls on the Island

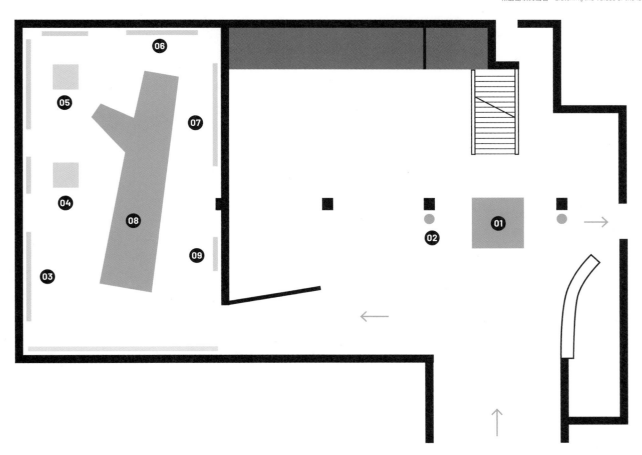

傾聽島嶼的聲音展場〈二〉：
南竿 53 據點
Stronghold no. 53, Nangan
26.1414986, 119.9167553

位於南竿西南邊津沙村南端近海處，
到訪者必須徒步進入據點範圍。主建
築左側有另一個地下坑道的入口，地
下坑道為原始岩脈開鑿而成，坑道出
口為臨海的雙層軍事建築，地下一層
為機槍射口，利用半島突岬的優勢，
觀察莒光海域的動向；地上一層則為
40 高砲陣地，開闊的視角搭配牆上繪
有地形圖，可以想像國軍當時駐守的
情況。

Located near the sea at the south end of
Jinsha Village in the southwest of Nangan,
Stronghold no. 53 is only accessible by foot.
The entrance to the underground tunnel,
which was cut by digging into the original
dyke, is positioned to the left of the main
building. Opposite is a two-story military
construction, with the lower floor being
housing for machine guns, taking advantage
of the cape location and being able to watch
the sea off Chukuang. The upper floor was
the launch base for Bofors 40 mm guns and
has a topographic map painted on the walls
that reveals the scenes experienced by the
army in earlier years.

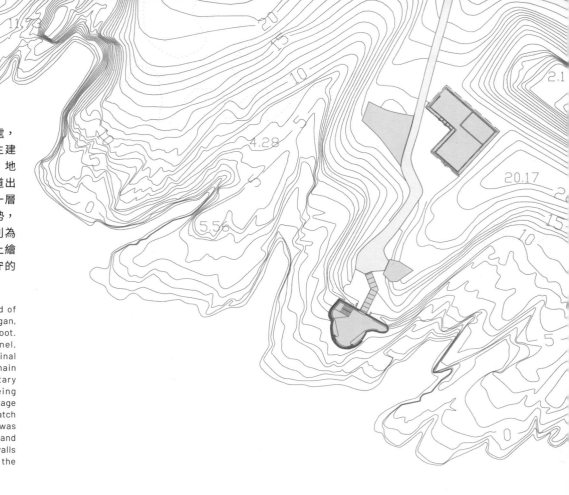

鄉音為響 –
有些字詞像鑰匙
Land and Lingo -
Words That Would Be Keys

蔡宛璇
Tsai Wan-Shuen

取材自劉宏文先生著作《鄉音馬祖》，創作者擇其文字世界中若干與過往島民集體記憶交相映照的平話（閩東語）字詞，讓它們被「說」和被「聽」。聽得懂的地方人或福州語使用者、聽不懂的地方人或對這個語言感到陌生的異鄉人，將在當中各自捕捉一些物質性的獨特音聲，以及非物質的殘響及漣漪。

—

📍 **南竿 53 據點**　26.1414986, 119.9167553

Locals who speak the native language, locals who do not speak the language, and those who are foreigners to the language will each capture from the artwork some of the materiality of the language's unique sounds as well as some of its non-material reverberations and ripples.

鄉音為響 – 言吾言寺
Land and Lingo-
The Poetic Tongue

蔡宛璇
Tsai Wan-Shuen

母語音義脈絡所召喚出的身體感知和記憶圖層，有時啟動著一種近乎直覺的認同感受。而在不諳該語言的人的聽覺感官中，所形成的特殊音樂性，則產生了另一層閱讀的可能，或者一些敘事空間的自由／刻板投射。

—

📍 **南竿 53 據點**　26.1414986, 119.9167553

The bodily perception and memory layers evoked by the phonological context of mother tongues sometimes activate an almost intuitive sense of identity. The specific musicality that develops in the auditory senses of those who do not speak the language creates another layer of reading possibilities.

駐波
Stationary Waves

澎葉生
Yannick Dauby

這件聲音裝置乃是特別籌備、安置於其聲學特性和意義能與物理空間產生對話的場域裡，提供觀眾實驗性的聽覺情境，且任由觀眾詮釋。

　　藝術家讓觀眾通過移動、坐下、站立等方式去探索這個空間。這是一個震動、震盪的空間，勾起遙遠的回聲、時間循環和無盡的傳言。觀眾想在這裡待多久就待多久。

The sound installation is an artwork of sound specifically prepared and placed in location where its acoustic properties and significance dialogue with the physical space, providing to the audience an experimental listening situation, open to interpretation.

—

📍 **南竿 53 據點**　26.1414986, 119.9167553

對象、景框、射口、掩體一窗
Objects, Frame, Loophole, Bunker - Frame

蕭佑任
Hsiao Yu-Jen

據點射口框出海，一片希望無人的海。射口的大小、比例與所望向的他方，觀看焦距來自武器與恐懼。焦距外的海岸在機能喪失後的掩體周圍向人們開放了，那些留下的痕跡是構成列島的最後一道邊界。

　　從那段因軍事被抹掉的灰色地帶中所發現的人造景觀中取出局部、放到據點的景框中，藉由喪失機能性的景框來觀看這段無人之境。

The artist takes parts of the artificial scenery in the gray zone, erased by the military, and puts them into the viewing frames of the stronghold to reveal the uninhabited area through the dysfunctional viewing frames.

—

📍 **南竿 53 據點**　26.1414986, 119.9167553

風化褶痕
Wind as Fold

蘇弘
Su Hung

端正 - 傾倒、設施 - 象徵、抵禦 - 再現、人 - 自然之間獨特關係，在耐候鋼的表面與連續皺褶中呈現，似曾相識的物件、不清晰的使用狀態與高強度的氣候風化之間，引領觀者想像並試探其獨特的存在狀態，形成與馬祖風土氣候的對話。

Familiar objects, an ambiguous state of use, and intense climatic weathering lead viewers to imagine and explore their unique states of existence, forming a dialogue with Matsu's terroir and climate.

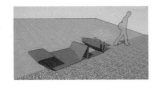

—
📍 **南竿 53 據點**　26.1414986, 119.9167553

換哨前的斜陽
The Sunset before the Relief of a Sentry

張靖騿、王嘉笙
Chang Ching-Huan,
Wang Chia-Sheng

陡峭的斜坡、狹窄的通道、扎人的植披，是通向大海絕景的考驗、也是進入南竿 53 據點臨海據高處的路徑。軍事背景的過去，成就了人們得以觀海望天的機緣，但對彼時駐守前線瞭望敵國的阿兵哥來說，枕戈待旦的肅殺，就像是一層可視卻不可觸的薄膜，禁制著軍士們回返日常的渴望。

Looking out to the sea through the bunkers' windows, the artists construct an inside-out, static-and-dynamic viewing scenario. The visual experience preserved in these bunkers will haunt the present from its silent, invisible past.

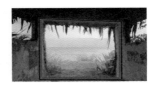

—
📍 **南竿 53 據點**　26.1414986, 119.9167553

折射島
Refracting Island

共感地景創作
ArchiBlur Lab

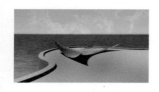

馬祖的戰地據點位址,是豐富「路徑」的層疊與交織——是歷史的路徑、地層變化的路徑,植物演替的路徑,聲音消長的路徑,季節風轉的路徑,故事的路徑,也是接近海的路徑,更是 一條探索消逝地景的路徑。《折射島》設置於馬祖南竿 53 據點路徑的末端,在最靠近海的據點屋頂,設置一片不鏽鋼組構的凹折地面,如同列嶼之間被拉伸、變動的海洋;承裝水與物種的容器,映射周遭的風景,與屋頂上重新聚積的風景共存;亦與身體的到訪共同折射出活的歷史。

—

📍 **南竿 53 據點**　26.1414986, 119.9167553

Refracting Island, located at the end of the Nangan 53 stronghold path, comprises several stainless steel teardrop-shaped volumes that reflect the surrounding scenery and coexist with the re-accumulated scenery on the roof, transmitting living history with the visit of the body.

拜訪瓊麻 2
Being around Sisal 2

王文心
Wang Wen-shin

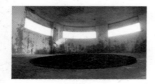

2020 年《拜訪瓊麻 1》的創作過程中,多次於荒廢已久的 53 據點停留,想著留在這裡的瓊麻,過的是什麼樣的時間?感受到的是什麼樣的光景?

　　「坑道都是水」是許多在待過這裡的記憶之一。一座荒廢的軍事據點,讓地面的水成為一種捕捉環境的裝置,通過捕捉邊界之外的事物將周圍的景觀作為場所本身;而水則成為製成反射面的原材料(Raw material)。

—

📍 **南竿 53 據點**　26.1414986, 119.9167553

The water on the ground of this deserted military stronghold captures the environment and incorporates the surrounding landscape into the site itself by capturing things outside the boundary. Water is used as a raw material to make the reflective surface.

枕待
Wait Till

鄒享想
Tsou Hsiang-Hsiang

《枕待》，源於馬祖著名的地標「枕戈待旦」，將其名詞捨去，剩餘的動詞恍若處於時光中漸漸遺忘的姿態，除卻了目的，未明地持續著。

化為廢墟的據點，猶如一則時空留下的寓言；穿梭在這空無靜謐的堡壘中，重新觸動了感官，持續地響應著這個地方。揉合自己在島嶼上的體驗，以整體意象或記憶片段，顯現於繪畫中，其中隱然可見場域裡的線索。

—

📍 **南竿 53 據點**　26.1414986, 119.9167553

The artist follows the clues in the military stronghold and compares the distinctive shapes of the machine gun embrasures, using the sense of volume as the vehicle of the painting, like a frame, and combining in the painting his perception of the island and the parallel perception of a military guard.

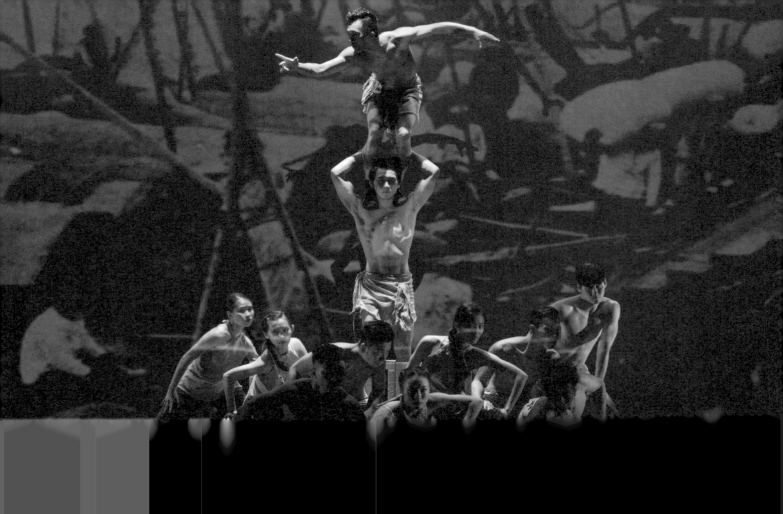

藝術計畫

島嶼生息

Ecology and Habitat of Islands

電，穿越流逝的歲月，陪伴著馬祖群島走過戰火、迎向現代。

　　回首過去，已不見戰地政務時期的宵禁和煙硝，獨留下吹著海風和望著星月的老電廠，陪伴著島嶼生息。本次策展以電力陪伴生活日常為發想，以藝術書寫著島嶼上的風土人情，透過邀請 4 組不同領域的藝術團隊，以不同的覺知，帶領著民眾體驗著馬祖群島的故事。

Through the passing years, electricity has powered the Matsu Islands through the war and into the modern era.

　　The curfews and gunpowder smoke of the war zone administration period are no more, but the aged power plants remains, feeling the sea breeze and gazing into the sky, accompanying the island as it lives and breathes. This exhibition, curated to express the idea that electricity accompanies daily life, uses art to document the island's people and customs. Four groups of invited artists from diverse fields lead the public to experience with multiple senses the stories of the Matsu Islands.

● 作品數量　4 件
📍 展出地點　南竿梅石營區鵲橋、南竿梅石聚落、南竿體育館、南竿福澳港

策展人────侯力瑋

任職於台灣電力公司公共藝術課。

　　透過光看見藝術，多年來致力於以藝術勾勒對於能源的想像，並且藉由藝術構築企業與民眾對話的可能。近來邀請許多跨領域之藝術創作者，共同以文化資產揉合文化藝術做形塑地方特色，期待能為台灣這塊土地創造更豐富的人文體驗。

Curator ─────── Hou Li- wei

As a member of the Public Art Division of the Taiwan Power Company, Hou Li-Wei has dedicated many years to envisioning energy through art and creating a dialogue between industries and the public through art. Recently, he invited many cross-disciplinary artists to collaborate in creating a richer human experience in Taiwan by combining cultural assets with cultural arts to shape local communities.

策展人────黃心瑜

出生於高雄，大港的女兒，台大工管系輔修社工系，試著用衝突的專業梳理複雜的當代社會議題，同時尋找自我價值與專業認同。具備理性策略思維，但選擇感性的社會參與藝術、審議式民主與藝術島籌備，作為社會實踐的領域，相信藝術有既溫柔觸動人心又尖銳批判的力量，能梳理社會關係，觀照生命與地方的意義。

Curator ─────── Huang Hsin-yu

Born in Kaohsiung, Huang Hsin-Yu graduated with a minor in social work from the Department of Business Administration at National Taiwan University. She employs the two seemingly discrepant areas of expertise both to establish her self-worth and professional identity and to address complex issues in contemporary society. In the field of social practice, she brings her rational logic to sensuous socially engaged arts, deliberative democracy, and the preparation of this Biennial. Huang believes that the gentle yet critical power of the arts can illuminate people's lives and communities through the interweaving of social relations.

搖欄
Balancing Act

何采柔
Joyce Ho

梅石營區特約茶室，一處以滿足駐島官兵性需求而設立的場域。留下的鵲橋之名，至今仍引人無限遐想。

　　藝術家在過去通往茶室的路徑中放置象徵禁錮的鐵欄杆並於底部設置搖籃的裝置，看似阻隔出內外空間彷彿回應當年茶室被束縛的心靈；卻僅能藉由中間預留的空隙，讓進入或是離開的定義顯得模糊。搖欄既剛硬又柔軟的反差所呈現的張力，一如特約茶室的存在，一個禁錮時代氛圍下的慰藉之所。本次作品希望透過風為作品啟動的動力來源，也如同風吹過的流逝歲月。

—

📍 南竿梅石營區鵲橋

Balancing Act is a cradle confined in iron railings that evoke the military brothels in Meishi barrack, a place of solace in the confined era. This work hopes to use the wind as a power source, reflecting the passage of time.

土地的歌
Songs of Land

FOCA 福爾摩沙馬戲團
Formosa Circus Art

本次演出以這片土地最原始的歌聲作為開端，帶來包括如大旗、武術、舞蹈、倒立、大環、立方體、扯鈴、疊羅漢等馬戲技巧的表演，並搭配著每個時期耳熟能詳的經典歌謠。此馬戲作品以選粹的方式呈現，從看見馬祖群島到擁抱島嶼，絕對是難得一見的馬戲歌舞劇作品。

—

🕐 **2022/3/12 19:00**
📍 南竿福澳港

The show starts with the primitive songs of Taiwan and presents circus skills such as flag dancing, martial arts, dance, handstands, cyr wheel and cube spinning, diabolo, and a human pyramid along with familiar Taiwanese classic songs from each period. It is undoubtedly a rare circus cabaret production.

微光。身影
The Gleaming Body

驫舞劇場｜蘇威嘉、方妤婷
HORSE | Su Wei-Chia, Fang Yu-Ting

《微光。身影》包含工作坊及演出兩個部分，希望透過編舞家蘇威嘉及舞蹈家方妤婷在馬祖駐地期間舉行工作坊，藉由自由步的技巧讓在地民眾及角力隊成員有機會去重新認識身體，並且開啟和身體對話的可能。

It is hoped that the free-stepping technique taught in the workshops held by choreographer Su Wei-Chia and dancer Fang Yu-Ting during their residency in Matsu will give local residents the opportunity to reacquaint themselves with their bodies and open up the possibility of dialogue with it.

🕐 **2022/3/2 - 2022/3/4 工作坊　2022/3/5 演出**
📍 **南竿體育館**

又是一個以漁村開頭的故事
Another Story Starting with a Fishing Village

鄭亭亭
Cheng Ting-Ting

《又是一個以漁村開頭的故事》為一聲音徒步旅程。在旅程中，我們藉由聆聽與行走，重新拜訪馬祖梅石特約茶室的文學和歷史，想像它的現在和未來。體驗方式：請使用手機掃描 QR Code，並依照 Google Map 指示前往路線起點，戴上耳機，並跟隨聲音指示前進。部分劇本引用自「那年在特約茶室」，舒暢及作家劉亦臉書文章。

Incorporating quotes from The Memory of the Military Brothels authored by Shu-Chang as well as from the writer Liu Yi on his Facebook, this work is an audio walk inviting visitors to revisit the history and the literature about the military brothels in Meishi barrack, picturing its past and future.

📍 **南竿梅石聚落**（出發點：梅石街區近海邊入口）

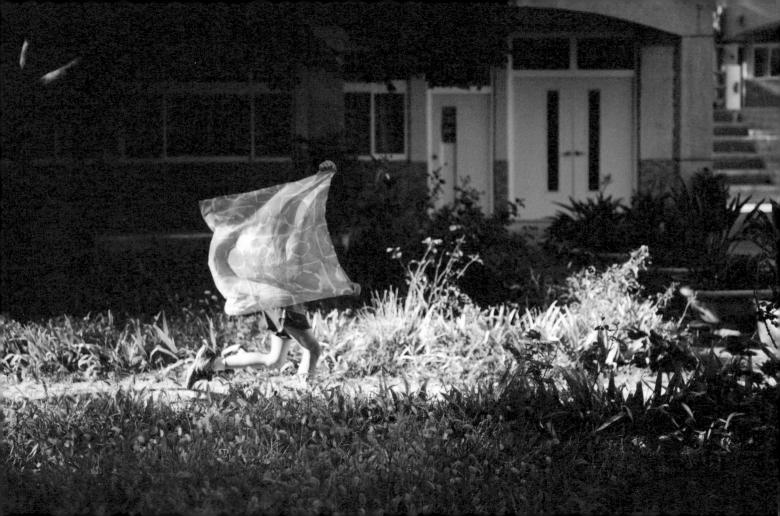

教育計畫

風塔：乘風而行的藝術共創旅程

The Tower of Winds

「風塔」策展概念起於馬祖先民乘風揚帆的旅程——當漁船選擇了一座島嶼定錨的瞬間，就如同風與土交會產生的震盪，在風化作用下雕出了五張不同的面孔。然而百年後，戰爭與政治的變遷束起這五條分合的緣分，捧起土壤，陌生的我們要砌一座塔，讓風代替火焰的攪動，滾動著彼此的異與同，創造出屬於「馬祖」轉生面貌。

The curatorial concept of The Tower of Winds derives from the sailing voyage of the ancestors of Matsu. When a fishing boat chose to anchor at one of the islands, it was as though the harmonies of the wind and the earth converged, the foreign and the local intersected, and five distinct faces were carved by the effect of weathering. A hundred years later, however, the exigencies of war and politics have bound together these five divergent frontiers. Resting on the soil, we, the strangers, build a tower, allowing the wind to replace the stirring of flames, blending one another's differences and similarities, and creating a reincarnation of Matsu.

由馬祖四鄉五島七所國小學生與師長共同創作：

連江縣立中正國民中小學｜林容安、孫顥仁、張紹哲、陳芊凝、陳玟汝、陳品旭、陳品澄、陳禹喬、陳禹甄、陳禹蓁、陳詩韻、陳學樂、游牧蓁、黃可媗、駱宇浠

連江縣南竿鄉仁愛國民小學｜王經榮、徐士荃、曹庭瑄、陳志霖、黃品維、劉歆恬

連江縣立介壽國民中小學｜王奐元、王思惠、池莫懷、林昀霏、林宣叡、姜澤宇、韋孟妘、曹辰睿、曹�117軒、郭采翎、陳明承、陳慈恩、陳語彤、陳擷安、鄧鈞和

連江縣立東引國民中小學｜王元希、李昇祐、李秉紘、林芷妤、林芷琦、陳泰霖、陳霈恩、彭柏諺、劉芊妤、劉堯輔、謝欣汝

連江縣莒光鄉東莒國民小學｜王春英、王雪金、周芷妍、周馳珺、姜佳妤、孫鈺茹、曹浩晶、曹詠晴、曹鳳金、曹劍蓉、陳芳喻、陳凌肴、彭敏如、曹美芳、劉倢伊、劉碧雲、鄭惠琴、韓昀庭

連江縣立敬恆國民中小學｜周子筠、曹宬浩、曹媛婷、陳紀宇、陳紀延、陳凌肯、黃淑萍、葉雪瑩、鄭媛娟

連江縣北竿鄉塘岐國民小學｜王又立、王佑嘉、王秀萍、王若芷、王熙評、宋陳睿、李奇恩、林品岑、張至妍、陳宇庭、陳宥宇、陳若愚、陳彩綺、陳楷中、黃鋙析

● 作品數量　1件
📍 展出地點　東引忠誠門前廣場草坪處

策展人 ——— 蔡沛原

景觀設計背景，原計畫赴歐研讀地景建築，卻在某夜受到海岸神祕的感召回到老家東引，就此誤入創生的旅途。以「北緯 26 度島嶼顏色」計畫蹲點地方進行切片式的色彩調查，將成果實踐於東引色彩改善工程中；將景觀思維活用於小島的公共設計，以「東引鄉門牌」獲得金點設計獎、iF Design Award。默默持續累積著景觀作品的同時，於東引島創辦鹹味島合作社，成為當地重要的地方共創基地。

Curator ——— Tsai Pei-Yuan

With a background in landscape design, Tsai Pei Yuan abandoned her plan to study abroad and began placemaking on her home islands. While quietly producing landscape works, he founded the Salty Island Studio on Dongyin Island, which has become an important foundation for placemaking.

策展人 ——— 林喬安

無法抗拒一切善美事物。台南藝術大學藝術史學系畢。曾任西洋古典珠寶藝術研究與策展主管，參與執行典藏館空間規劃、蒐藏登錄、研究與策展，該展示設計入圍 INSIDE WAF award 2019。為親海移居邊陲小島，現職為東引國小藝術教師，於此探索人文與土地純粹的共振關係。

Curator ——— Joanne Lin

Joanne Lin, who was involved in the spatial planning, registration, research, and curation of the collection hall of, which was shortlisted for INSIDE WAF award 2019. Relocated to Matsu to be close to the sea and now works as an art teacher in Dongyin Elementary School, where she explores the pure, resonant relationship between the humanities and the islands.

風塔：乘風而行的藝術共創旅程
The Tower of Winds:
A Journey of Artistic Co-creation
on the Wind

馬祖四鄉五島七所小學
學生與師長共同創作

利用各島採集之不同顏色的天然土壤，加上請學生各自採集的植物染出屬於每個島嶼獨特的顏色。白色的布料象徵「船帆」，代表馬祖先民乘船移居的歷史，象徵著馬祖人乘風而行的基因故事；泥染則連結著四鄉五島的土地，象徵於土地扎根。

—

📍 東引忠誠門前廣場草坪處

Children are invited to collect plants to create dyes unique to each island, and soils collected from each island are used. The white fabric symbolizes "sails", representing the history of the ancestors who migrated by boat while the blue dye symbolizes the sea that connects all the islands.

風塔：裝置共創活動
The Tower of Winds:
Installation Co-creation Activities

馬祖四鄉五島七所小學
學生與師長共同創作

以青竹構塔，延續馬祖傳統漁用尼龍繩「曬衣」概念，將馬祖小學生創作之泥染布塊攜至代表共同文化的塔上，當海風貫穿時可隨風飄揚，象徵著「風帆」的意象。裝置質感效仿馬祖的日常風景，更隱藏了十年共創馬祖的期許。

—

🕐 **2022/2/18**
📍 **東引忠誠門前廣場草坪處**

The tower is constructed of bamboo. By continuing the traditional of Matsu, which is to hang clothes on fishing nylon ropes to dry, the mud-dyed cloth that symbolizes the wind sail is carried up the tower and raise against wind. The texture of the installation emulates the everyday scenery of Matsu.

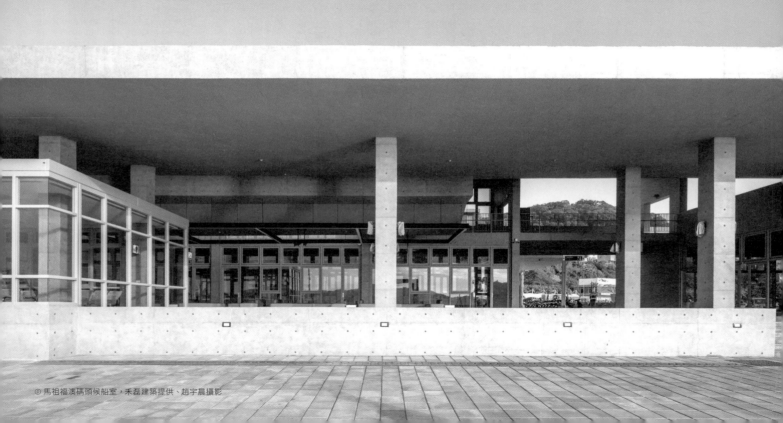

© 馬祖福澳碼頭候船室，禾磊建築提供、趙宇晨攝影

一幅

lands

一幅

完成中的

完成

風景

volution.

風景

建築計畫

一幅完成中的風景

Islands in Evolution

以馬祖後戰地政務時期變遷 30 年為軌跡，盤點近 30 個聚落或建築特色空間，審視這些空間如何與馬祖當代生活產生對話。面對國際藝術島，這是一個給馬祖人的新舊紀事指引，也給未來即將來馬祖的人們——可能是觀光，也可能是生活者、創作者、設計者等多樣族群的「新馬祖人」，共同持續投入這「一幅完成中的風景」。

Taking Matsu's 30-year postwar administrative period as its impetus, this exhibition takes stock of nearly 30 settlements or architectural spaces and examines how they are in dialogue with the contemporary life of Matsu. In the context of the international art season, it represents a guide to the old and new chronicles of Matsuers as well as the stories of future Matsuers, who may be tourists, creators, designers, or others who will continue to work on this "islands in evolution."

● 作品數量　1 組空間展覽
● 展出地點　南竿福澳碼頭候船室

策展人————劉柏宏

1961 年生於高雄,早期作品為景觀工程,後因女兒上小學轉而關注參與式設計領域逾 30 年。近年作品注重環境與人的共生關係,將使用者的習慣、記憶與新的需求融合。獲獎作品包括台 9 線花蓮路段提出「以路就樹」國際景觀建築師協會景觀大賞卓越獎(2019 IFLA-APR LA Awards)、2020 年以《魚木的心跳》作品榮獲文化部公共藝術卓越獎等最高殊榮。自 2015 年起任連江縣景觀總顧問迄今。

Curator ———— Liu Po-Hung

Born in 1961 in Kaohsiung, Liu worked initially in the field of landscape engineering and then, when his daughter entered elementary school, turned his attention for over 30 years to participatory design. His recent works, focusing on the symbiotic relationship between people and the environment, integrate user habits and memories with new needs. His work has been honored with the 2019 IFLA-APR LA Award for Excellence in Landscape Architecture (for Road with Trees, the Hualien section of Taiwan's Route 9) and the Ministry of Culture's Award of Excellence in Public Art for The Heartbeat of Spider Tree in 2020. He has been the General Landscape Consultant of Lianjiang County since 2015.

一幅完成中的風景
Islands in Evolution

穿過這一座過境之道，10 幅不同時代的風土影像作品將引領觀眾在跨時空敘事中穿梭島嶼的前世今生。藉由 3 幅插畫再詮釋島嶼的記憶與表情，而 3 座以澳口為文本的虛實交織地景作品提供馬祖未來之境的凝視。看見與馬祖列嶼並進的百年時空，與持續遞嬗的島嶼風景。島嶼，演進中 Islands in evolution 。

Ten images of different eras will guide the audience through the past and present of the island in an inter-temporal narrative. Three illustrations reinterpret the memories of the islands, while three interwoven real and virtual landscapes based on the text of bay provide a gaze into their future.

展出作品
Exhibited Works

登島 *On to the Island*
給島的備忘錄 *A Memorandum for the Islands*
與海的距離 *Distance from the Sea*
映畫馬祖 *Images of Matsu*

—
🔘 南竿福澳碼頭候船室

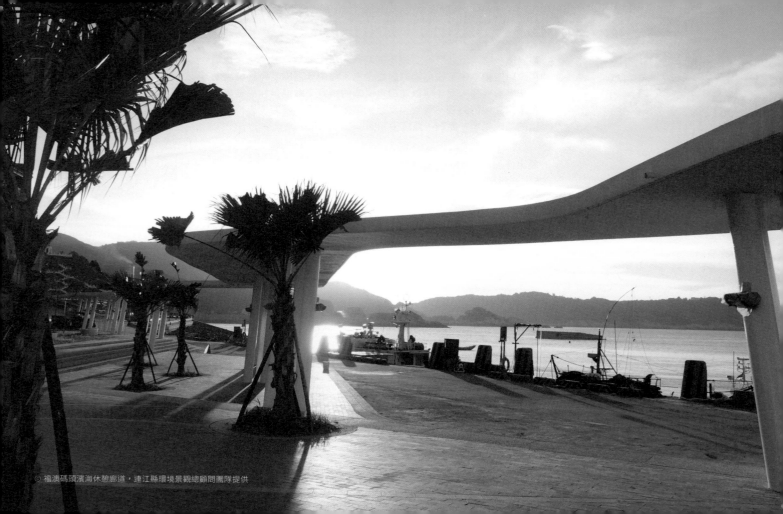

◎ 福澳碼頭濱海休憩廊道，連江縣環境景觀總顧問團隊提供

當代建築選件

Highlights of Contemporary Architecture in Matsu

在北緯 26 度的國之北疆，馬祖有著與台灣本島截然不同的地理與歷史背景，火成岩大陸島及閩東文化的影響鮮明地反映在建築上，先天資源的限制也使建築與環境的關係始終緊密。

如何以現代材料詮釋傳統語彙亦不失脈絡紋理？如何回應基地本身議題，從而形成馬祖當代建築的自明性，並與在地營造廠以夥伴關係彼此學習，突破熟悉的技術工法？這些都是如風一般到島上的建築師們的重要課題。因此，我們自公共建設中挑選出福澳碼頭濱海休憩廊道、馬祖福澳碼頭候船室，以及梅石營區軍官、士兵特約茶室作為第一屆馬祖當代建築選件。

3 件作品皆不只是單一獨立的建築，也扮演定錨一個區域未來發展的起始空間，不論是梅石區域或是福澳港周邊的發展仍滾動進行中，都將影響馬祖接下來的發展。期盼馬祖國際藝術島將建築與景觀納入作品的策劃機制，醞釀更成熟的公共討論機制，與後續營運規劃，讓更多公眾的視野投注於此，在解除戰地政務管制後的蓬勃發展之下，能避免可預見的環境衝擊，把關當代島嶼的樣貌。

Situated on the nation's northern frontier at the 26th parallel, Matsu has experienced geological and historical developments that were poles apart from those of the island of Taiwan. The igneous bedrock of Matsu's continental islands and the cultural influence of the Eastern Min are vividly manifested in the architecture, and the limitations of the islands' natural resources also intimately inform the environment and architecture of Matsu.

The architects who have visited the islands have influenced the emergence of Matsu's contemporary architecture by expressing the traditional culture in modern materials in a relevant context that responds to the architecture, all while facing the challenges of adopting unfamiliar construction methods and learning from local construction partners. We have selected a number of public constructions, including *The Recreation Corridor along the Fu'ao Harbor,* the *Passenger Waiting Room of Fu'ao Harbor*, and *Meishi Teahouse 831 (Renovation of Military Brothels)*, as the first-ever highlights of contemporary architecture in Matsu.

These three works of architecture are not merely buildings but also comprise the initial loci of future development in their areas. Whether in the Meishih district or the vicinity of Fu'ao Harbor, the ongoing development of these places may determine the future of Matsu. As a curatorial team, we were obliged to incorporate the architecture and landscapes of Matsu in curating this Biennial, brewing a maturer draft for discussions of public matters and plans for future development. By embracing public opinion, we wish to avert the foreseeable environmental impacts threatened by the booming development of the Matsu Islands after the war zone administration, watching out for our contemporary islands.

● 作品數量　3 項選件　　● 展出地點　南竿福澳港碼頭周邊、南竿福澳港、南竿梅石

選件人────**褚瑞基**

畢業於賓州大學建築系。返台後任教於銘傳大學建築系,並於多所大學系所教授建築史及建築理論。關注城市設計、公共藝術、城鄉發展以及社區營造,並撰寫許多有關建築思維、設計理論的書籍,也進行許多公共藝術、藝術介入社區的活動、計畫及展演。著有許多書籍,包含《人與自然》、《建築歷程》、《建築之書》、《卡羅‧史卡帕:空間中流動的詩性》等。

Commissioner ──── Ray Chu

Ray Chu received Master degree from University of Pennsylvania and worked for Louis I. Kahn Foundation. Since his return to Taiwan, he has taught in several Universities. Currently he is associate professor in Ming Chuan University and leads his team involving many community empowerment projects and public art projects for governments.

選件人────**劉柏宏**

1961 年生於高雄,早期作品為景觀工程,後因女兒上小學轉而關注參與式設計領域逾 30 年。近年作品注重環境與人的共生關係,將使用者的習慣、記憶與新的需求融合。獲獎作品包括台 9 線花蓮路段提出「以路就樹」國際景觀建築師協會景觀大賞卓越獎（2019 IFLA-APR LA Awards）、2020 年以《魚木的心跳》作品榮獲文化部公共藝術卓越獎等最高殊榮。自 2015 年起任連江縣景觀總顧問迄今。

Commissioner ──── Liu Po-Hung

Born in 1961 in Kaohsiung, Liu worked initially in the field of landscape engineering and then, when his daughter entered elementary school, turned his attention for over 30 years to participatory design. His recent works, focusing on the symbiotic relationship between people and the environment, integrate user habits and memories with new needs. His work has been honored with the 2019 IFLA-APR LA Award for Excellence in Landscape Architecture (for Road with Trees, the Hualien section of Taiwan's Route 9) and the Ministry of Culture's Award of Excellence in Public Art for The Heartbeat of Spider Tree in 2020. He has been the General Landscape Consultant of Lianjiang County since 2015.

馬祖福澳碼頭候船室

Passenger Waiting Room of Fu'ao Harbor, Matsu

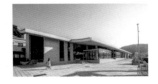

透過水平開展的弧形大屋頂，我們將南竿福澳港的碼頭水岸重新打開，建構山與海之間通透的交會點。斜向的大屋頂一方面呼應了島嶼岩壁的地勢，一方面以現代建築語彙和地方傳統建築的形式對話，形成新的馬祖地景建築。新的馬祖福澳碼頭候船室提供舒適的候船空間，完備島際轉運的功能，同時也將成為居民休憩交誼的生活場所。從屋頂大尺度切開形成的二樓觀景平台，連結一樓開放空間提供人們不同角度與高度的展望，可充分感受馬祖的山、海、風、陽光、與馬祖建立新的親密關係。

規劃統籌　合圃股份有限公司 FID-TEK International Consultants Co., LTD.
建築設計　禾磊建築 + 李訓中建築師事務所
　　　　　Architerior Architects + SJ LEE ARCHITECTURE
設計團隊　禾磊建築 / 梁豫漳、蔡大仁、吳明杰、陳科廷
　　　　　Architerior Architects / Yu-chang Liang、Da-ren Cai、Ming-jet Wu、Ke-ting Chen
　　　　　李訓中建築師事務所 / 李訓中、卞燕玲、楊昀樺 SJ LEE ARCHITECTURE /Sam Lee, Pien Yen-Ling, Yang Yun-Hua
結構設計　築遠工程顧問有限公司 Envision Engineering Consultants
機電設計　泓翊機電工程顧問有限公司
　　　　　Honeei Mechanical and Electrical Engineering Co.,Ltd.
建築監造　李訓中建築師事務所 SJ LEE ARCHITECTURE
施工廠商　上升營造有限公司、國閎營造有限公司
　　　　　RISE Construction Co., Ltd、GuoHong Construction Co., Ltd

—

📍 南竿福澳港

Using a horizontally extended bowstring roof, we opened up the waterfront of Fu'ao Harbor in Nangan, establishing an intersection between the mountains and the sea. On the one hand, the sloped roof echoes the island's craggy terrain; on the other, it enables a dialogue between modern and traditional architectural styles, creating a new landscape of Matsu. The recently built Fu'ao Harbor Passenger Waiting Room offers a cozy terminal space that both welcomes passengers after their inter-island journey and provides space for the islanders' social and recreational lives.The massive viewing deck on the second floor, split by the roof, connects to the open space on the first floor, providing views from different angles and heights, allowing people to immerse themselves in the mountains, waters, wind, and sunshine of Matsu and thus nurture their own intimacy with the island.

—

構造材料：清水混凝土、灰磚、金屬、玻璃
基地面積：9490 m²
建築面積：2980 m²
樓地板面積：3250 m²
層數（地上、地下）：地上 2 層
設計時間：2018-2019
施工時間：2019-2021

福澳碼頭濱海休憩廊道
The Recreation Corridor along Fu'ao Harbor

為營造福澳港周邊優質休閒環境、豐富港口海景、促進開放空間利用，本計畫改善北起港口候船大樓南至魚市場（星巴克）周邊公園的人行環境與活動空間，以仿波浪的曲線造型為主要語彙設計花臺、階梯、廊架以形塑優質的步行廊帶，並增設共融遊戲場、提高綠覆環境，使整體環境兼具觀光遊客與常民活動需求。

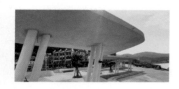

設計團隊	一口規劃設計顧問有限公司 / 宋鎮邁
	Ecoscope
	合圃股份有限公司
	FID-TEK International Consultants Co., LTD.
結構設計	知成土木結構技師事務所
	SUP Civil and Structure Engineering Firm
工程監造	合圃股份有限公司
	FID-TEK International Consultants Co., LTD.
施工廠商	上升營造有限公司、國閎營造有限公司
	RISE Construction Co., Ltd、
	GuoHong Construction Co., Ltd

To facilitate leisure activities, enhance the views of the waterfront, and encourage the use of public spaces around Fu'ao Harbor, this project revamped the walkways and activity spaces between the terminal building and the fish market (Starbucks). A wave-like shape, the primary motif of the parterres, stairs, and gallery, lends an aesthetic dimension to the experience of walkers. An inclusive playground with a broad green space additionally meets the needs of tourists and residents.

—

📍 南竿福澳碼頭周邊

—

構造材料：混凝土、抿石子、金屬、植栽
基地面積：13.000 m²
設計時間：2018.02-2018.12
施工時間：2019.01-2021.10

梅石營區軍官、士兵特約茶室

Meishi Teahouse 831
(Renovation of Military Brothels)

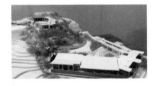

士兵茶室順應地形呈現獨特的 V 型配置，V 型轉折處迷彩外牆與中庭的防空洞散發著濃厚的戰地氛圍。本區保留大廳既有牆面及空間配置，並以 RC 剪力牆共構補強，形成牆厚超過 40cm 的複合構造，陰翳的光線經由厚牆上的開口透入室內，提供了獨特的歷史展示空間。

軍官茶室未來將委外經營，作為結合特約茶室歷史展示與旅宿空間的「特約文化客棧」，除保留娛樂券售票口、原有侍應生套房格局外，也將散發歡愉氣息的天藍色、粉紅色面漆作為保存重點，提供旅人獨一無二的住宿體驗。

建築設計	立建築師事務所 AMBi Studio
設計團隊	立建築師事務所 / 廖偉立建築師、任慶力建築師、魏惟、林潔珊、范聿睿、侯巧蓁、楊忠翰、閆和均
	AMBi Studio/Liao Wei-Li, Ren Cing-Li, Wei Wei, Lin Jie-Shan, Fan Yu-Ruei, Hou Ciao-Jhen, Yang Jhong-Han, Yan He-Jyun
結構設計	鼎匠工程顧問公司
	Top Technic Engineering Consultants Co., Ltd.
機電設計	冠昇工程設計事務所
	Guansheng Engineering Design Office
建築監造	立建築師事務所 AMBi Studio
施工廠商	聖育營造有限公司 王清勇（軍官）
	崇雅營造有限公司 廖明彬（士兵）
	FUGUACH ARCHITECTURE

—

📍 **南竿梅石**

Accommodating the natural terrain, the soldiers' section of this military brothel is configured in a unique V shape, with the camouflaged outer walls at the corner of the V and the air-raid shelter in the courtyard telling the history of wars. Maintaining the original walls and space allocation of the lobby, the architectural structure of this section is strengthened by reinforced concrete shear walls, making it a hybrid structure with walls over 40 cm thick. Light and shadow come through the openings in the walls, giving the space's historical exhibition an unparalleled ambiance. The officers' section will be reimagined as a "special cultural hotel" that incorporates lodging with an exhibition on the history of this military brothel. In addition to its original ticket counter and the spatial distribution of the rooms, the hotel retains the walls' joyful sky blue and pink colors to offer a one-of-a-kind lodging experience.

—

構造材料：木紋清水混凝土、鋼構、烤漆鋁板
基地面積：軍官 3820.61 m² / 士兵 904.54 m²
建築面積：軍官 817.25 m² / 士兵 915.5 m²
樓地板面積：軍官 1176.97 ㎡ / 士兵 904.54 m²
層數（地上、地下）：軍官地上 2 層 / 士兵地上 1 層
設計時間：2018-2019
施工時間：2019-2021

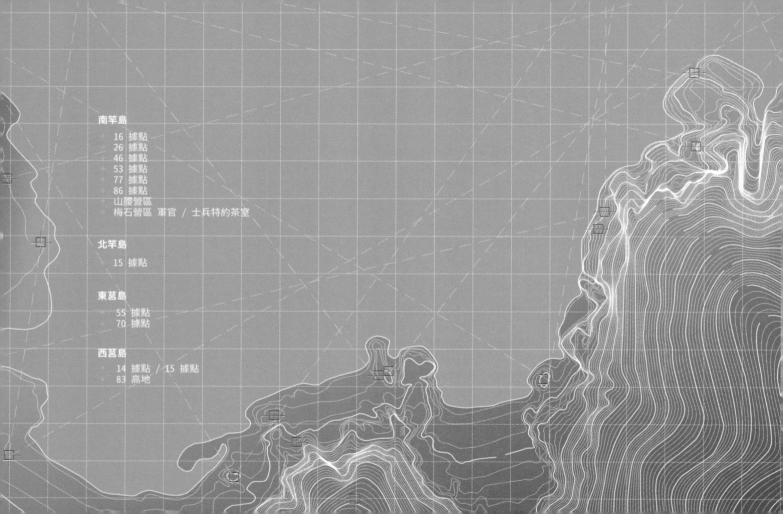

南竿島
16 據點
26 據點
46 據點
53 據點
77 據點
86 據點
山腰營區
梅石營區 軍官 / 士兵特約茶室

北竿島
15 據點

東莒島
55 據點
70 據點

西莒島
14 據點 / 15 據點
83 高地

戰地轉身・轉譯再生

Translating and Regenerating the Military Heritage in Matsu

遍布於馬祖四鄉五島的軍事據點，是逐漸被淡忘卻無法癒合的歷史痕跡，這些成為現今文化遺產的據點，雖是居民眼裡的尋常風景，卻常被排除於日常生活之外。

　　國立成功大學自 2020 年投入「戰地轉身・轉譯再生——統籌執行計畫」至今已近兩年，其中軍事文化遺產的轉譯再生是此計畫關鍵策略之一，成大執行統籌與策略規劃，整合各階段介入的建築設計團隊，輔助團隊設計、再造逐漸頹圮或消失的軍事據點，使其逐步融入馬祖的當代生活，也成為連結國際的展示平台，開發永續經營的潛能。

　　目前計畫選定已釋出的營區與海防據點作為轉譯基地，包括南竿 16 據點、26 據點、46 據點、53 據點、77 據點、86 據點、梅石營區、北竿 15 據點、東莒 55 據點、70 據點、西莒 14 據點、15 據點、85 高地共 13 組，透過知名得獎建築團隊的專業洞見，以不同的策略與觀點介入，從過去的時空背景到未來的空間故事，提取淬煉出可能的轉譯設計構想，賦予軍事遺產新的時代意義與當代性。

The military strongholds scattered across the four villages and five islands of Matsu are traces of a history that is gradually being forgotten and yet cannot be healed. Although these military strongholds are considered cultural heritage, they are a commonplace sight in the eyes of Matsu residents while being alien to their daily lives.

　　National Cheng Kung University (NCKU) invested in the "Translating and Regenerating the Military Heritage in Matsu" project from 2020. A key strategy of this project is the interpretation and regeneration of military cultural heritage, with NCKU acting as the coordinator and strategic planner. The university is integrating the architectural design teams involved at various stages, assisting them to redesign military strongholds that are steadily falling into disuse or oblivion. The goal is to gradually integrate them into the contemporary life of Matsu, transforming the military strongholds into showcasing platforms for international connections, and tapping into their potential for future sustainable development.

　　Currently, 13 groups of decommissioned barracks and naval defense strongholds have been selected as bases for translation in the regeneration project, including strongholds 16, 26, 46, 53, 77, 86, and Meishih Camp in Nangan, no. 15 in Beigan, no. 55 and 70 in Dongju, and Xiju's strongholds no.14 and 15 as well as highland no. 85. A renowned, award-winning architectural team will provide professional insights from diverse strategies and perspectives, extracting and refining possible design ideas from the context of the past to the spatial story of the future, endowing the military heritage with new, contemporary meaning.

● 作品數量　1組空間展覽　　● 展出地點　南竿梅石軍官特約茶室　26.147306, 119.937861

策展人———— **傅朝卿**

英國愛丁堡大學建築博士，國立成功大學建築系名譽教授，長期專注於台灣近現代建築史與文化資產保存維護。曾為「台灣建築摩登化的故事──走過一個半世紀的台灣近現代建築特展」與「台南市文化資產大展」等多項建築展的策展人。

Curator ———— Prof. Fu Chao-Ching

Prof. Fu Chao-Ching earned a doctorate in architecture from the University of Edinburgh (UK) and is a Professor Emeritus in the Department of Architecture at National Cheng Kung University. He has long focused on the history of modern architecture and the preservation of cultural assets in Taiwan. Prof. Fu has been the curator of many architectural exhibitions, including "Special Issue of the Exhibition on Modern Architecture in Taiwan since the Middle of the Nineteenth Century" and the "Tainan City Cultural Property Exhibition."

策展人———— **鄭泰昇**

主要研究「建築資訊模型」、「人機互動」、「智慧空間」、以及數位媒體在建築環境相關的應用，擅長運用最新數位科技研發創新的建築與設計技術，將空間本身視為互動介面的一部分，整合實體空間與虛擬空間，建構未來的互動式媒體空間。

Curator ———— Prof. Jeng Tay-Sheng

Prof. Jeng Tay-Sheng's main research areas are building information modeling (BIM), human-machine interaction, smart spaces, and digital media applications in the building environment. He specializes in the development of innovative architectural and design techniques using the latest digital technology.

策展人———— **龔柏閔**

現任成功大學建築系講師及設計中心執行長。成大設計中心執行許多校園空間相關規劃與設計提案，近期更協助成大規劃九十周年校慶活動及「校園生活特展」，展示成大九十年來的學生生活與校園空間的變遷。

Curator ———— Kung Po-Min

Kung Po-Min is currently the executive director of NCKU Design Center. The center recently assisted NCKU in planning its 90th anniversary celebration and the Special Exhibition of Campus Life, which showcases the changes in student life and the campus space over the past 90 years.

戰地轉身 · 轉譯再生

*Translating and Regenerating
the Military Heritage in Matsu*

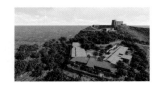

遍布馬祖的海防據點，在空間分布及組織上存在著相互串連及支援的關係；經過設計改造後的據點提案也應該藉此特性串聯其不同的屬性，擴展最大的效應。本展藉由一樓較為規矩的空間布置，轉上二樓明亮而開闊的展覽空間，象徵馬祖由過往的封閉狀態，透過不同觀點的設計策略介入，迎向多元且充滿可能性的未來。

展出作品
Exhibited Works

馬祖 北竿 15 據點 *No.15, in Beigang, Matsu*

二十公里外的凝望 _ 西莒的日常再造
Staring from 20 km away_Reconfiguration of day to day life in Xiju island

溜境 *NO. 16, Slide*

海角藝隅 *No. 26, An Art Corner to Taste*

(偽) 自然。環境劇場 *Bunker the Nature, Landscape as Theater*

海上鋼琴吧 *No. 53, Piano Bar*

光影美術館 *Light Art Museum*

防線公園 *Defense Park*

等待美術館 *Seventy Seven Gallery*

「從神秘到神奇」馬祖轉譯—解構西莒光 85 高地
Matsu : From Mysterious to the Magical

介閱：感知圖書館 *Perceiving Through the Layers*

南竿日常。軟公共
Soft Commonality - 8 Actions to Revive Public Spaces in Nankan Township

梅石營區 軍官 / 士兵特約茶室
Meishi Teahouse 831 (Renovation of Military Brothels)

—

📍 **南竿梅石軍官特約茶室** 26.147306, 119.937861

The naval defense strongholds throughout Matsu are spatially distributed and organized in a contiguous and collaborative relationship; the modified stronghold proposals should expand on this correlation to connect their different attributes and maximize their effectiveness. The exhibition begins with a regular and rigid arrangement on the first floor, then develops into a bright and open space on the second floor, symbolizing Matsu's restrained past, through the intervention of different perspectives and design strategies, welcoming a diversified future full of possibilities.

島嶼釀・馬祖國際藝術島 2021-2022

指導單位
文化部
交通部
交通部觀光局
國家發展委員會
陳雪生立委辦公室
連江縣議會

主辦單位
中華文化總會
連江縣政府

協辦單位
交通部觀光局馬祖國家風景區管理處
陸軍馬祖防衛指揮部
桃園市政府文化局
基隆市文化局
新竹市文化局
國立臺灣海洋大學
國立台灣交響樂團
南竿鄉公所
北竿鄉公所
東引鄉公所
莒光鄉公所

承辦單位
連江縣政府文化處
馬祖國際藝術島專案辦公室

贊助單位
合作金庫商業銀行 穩懋半導體股份有限公司
台灣集中保管結算所 證券櫃檯買賣中心
中華電信股份有限公司 全家便利商店 台灣電力公司

特別感謝
立榮航空 長汎假期 台灣觀光協會 台灣索尼股份有限公司
Swiper 滑吧 公益財團法人日本台灣交流協會

總策劃
吳漢中

行銷統籌
程詩郁｜左腦創意

策展團隊（策展人｜團隊）
曹楷智、劉宏文｜地下工事在地顧問 林怡華｜山冶計畫
黃鼎堯｜耕藝耘術有限公司 陳泳翰｜大浦plus+
陳宣誠、廖億美｜好多樣文化工作室
侯力瑋｜台電公共藝術 黃心瑜｜寧淨國際
蔡沛原｜鹹味島合作社 林喬安｜連江縣立東引國民中小學
劉柏宏｜原典創思規劃顧問有限公司
褚瑞基、劉柏宏｜馬祖當代建築選件人
鄭泰昇、傅朝卿、龔柏閔｜國立成功大學規劃與設計學院

協力團隊
愛樂劇工廠（財團法人台北愛樂文教基金會） 小島旦
新竹青年國樂團 新莊瘋薩客樂團 文化志工

國家圖書館出版品預行編目（CIP）資料

島嶼釀：馬祖國際藝術島 2021-2022 = Island brew /
李取中總編輯. -- 初版. -- 連江縣南竿鄉：連江縣政府,
2022.01
152 面；21 x 14 公分
ISBN 978-986-5468-62-0(精裝)

1.CST: 自然景觀 2.CST: 攝影集 3.CST: 福建省連江縣

957.2　　　　　　　　　　　　　　110022406

島嶼釀・馬祖國際藝術島 2021-2022

發行人
劉增應
中華文化總會

出版單位
連江縣政府
網站 www.matsu.gov.tw
地址 連江縣南竿鄉介壽村76號
電話 0836-22393
傳真 0836-22584

行銷策劃
左腦創意

編輯策劃　編集者新聞
總編輯　　李取中
專案主編　林鈺雯
特約攝影　林科呈
特約撰述　黃開洋
英文翻譯　方凱平
英文審校　汪怡君
文稿校對　劉佳旻
美術設計　陳映慈
圖像提供　各計畫與策展團隊
　　　　　p.63,64 連江縣政府文化處提供
印刷裝訂　科億資訊科技有限公司
發行策劃　編集者新聞社有限公司

GPN　　　1011100053
ISBN　　 9789865468620
初版一刷　2022年1月
定價　　　NTD$580